Remembering Hoboken

Joe Czachowski

TURNER
PUBLISHING COMPANY

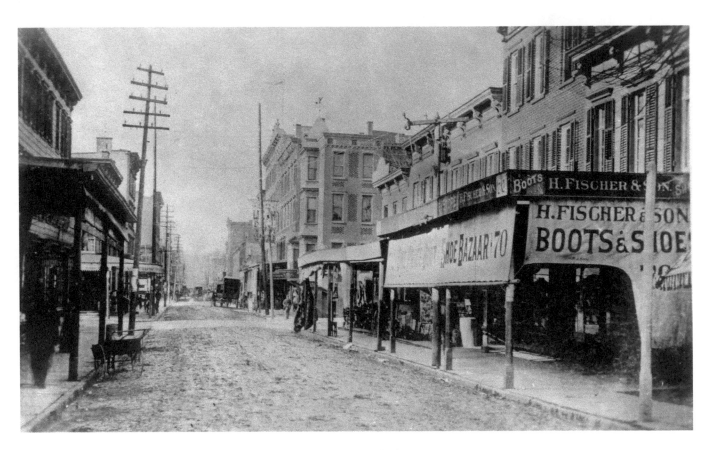

Fischer's Boots & Shoes was located on 1st Street, as seen in this view looking west.

Remembering
Hoboken

Turner Publishing Company
4507 Charlotte Avenue • Suite 100
Nashville, Tennessee 37209
(615) 255-2665

Remembering Hoboken

www.turnerpublishing.com

Library of Congress Control Number: 2010926213

ISBN: 978-1-59652-689-1

Printed in the United States of America

ISBN-13: 978-1-68336-837-3 (pbk)

CONTENTS

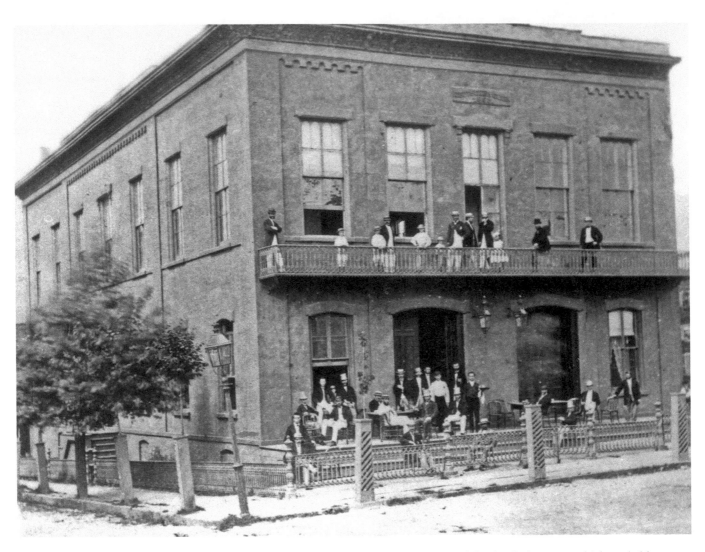

Members of the Hoboken German Club, also known as the Union Club, have gathered for the day's events, which probably included posing for this mid-1860s photograph. The club was organized in 1857, and the building was located at the northwest corner of 6th and Hudson streets.

Acknowledgments

Except for cropping images where needed and touching up imperfections that have accrued over time, no changes have been made to the photographs in this volume. The caliber and clarity of many photographs are limited by the technology of the day and the ability of the photographer at the time they were made.

This volume, *Remembering Hoboken,* is the result of the cooperation and efforts of many individuals and organizations. It is with great thanks that we acknowledge the valuable contribution of the following for their generous support:

Hoboken Public Library

New Jersey State Archives; Department of State

PREFACE

If you study New Jersey history, you will invariably encounter somewhere a statement along the lines of "New Jersey lives in the shadow of New York and Philadelphia." We roll with the punches here in Jersey, though, and have a few choice comments about that perception. However, when it comes to Hoboken specifically, the New Jersey port city did grow up in the shadow of a metropolis: New York. How Hoboken came into being, thrived, nearly died, and was revived, is a true American blue-collar success story.

In olden days Hoboken was a short boat ride from New York City, so in the bloom of spring, the wilting of summer, and the onset of autumn, New Yorkers would cross over the Hudson River and stroll along its western bank or through the Elysian Fields for a respite from the crowded city. Hoboken was a part of the natural harbor, so it was only a matter of time before it became an integral part of the economic system of the entire area. The city's growth brought immigrants looking for work, which they found first in the shipping business, then in manufacturing and transportation. Hoboken became a hard-working, tough, immigrant city, a draw for the Italian, German, Dutch, Irish, and Eastern European masses who yearned for that breath of fresh air on America's golden shores.

Hoboken can claim its fair share of firsts. In 1663, America's first brewery was patented at Castle Point. With all apologies to Cooperstown, New York, Hoboken hosted the first organized baseball game, on June 19, 1846. The first zipper was manufactured by Hoboken's Automatic Hook & Eye Company. Thomas Edison drove the first electrified train from Hoboken's Delaware, Lackawanna, & Western Terminal to Montclair, New Jersey. Colonel John Stevens, whose family was responsible for establishing most of the town and also Stevens Institute of Technology, ran the first steam-powered ferry and implemented technical changes that enabled steam locomotives to be adapted from the English version to the American type that eventually spanned the continent. His son Robert Stevens designed the "T-rail" track still used in railroad engineering today. The Blimpie brand of fast-food sandwich was first served on Hoboken's Washington Street.

A Hoboken location served as inspiration for Edgar Allan Poe's eerie tale "The Mystery of Marie Roget." The city's name has been used in entertainment settings from Looney Toons cartoons to a *Twilight Zone* episode. Hoboken's famous residents have included the artist Willem de Kooning, the actress and *Titanic* survivor Dorothy Gibson, the sex researcher Alfred Kinsey, the alternative rock band the Bongos, and that somewhat successful singer Francis Albert Sinatra.

With success comes eventual downturn. Hoboken's rise was high and fairly consistent for a number of decades, but its demise was swift. In the mid-1950s, the city was used as a backdrop for the Academy Award–winning film *On the Waterfront*. The black-and-white film with its stark contrasts seemed to cast a pall over the real city. The shipyards began to close and were gone by the late 1960s. Manufacturing was relocated, and the city became depressed economically as well as socially and spiritually. The heart of the city became chilled. The sun continued to rise, however, and someone remembered what Hoboken was in the first place: a welcome respite from the city.

As business boomed in New York City, Hoboken's land value increased. Old factories and abandoned warehouses were either removed or converted to apartments and condominiums. A new wave of transplants came to Hoboken and brought it back to its former identity as a vibrant city of people, culture, and history. As I sat in a park across from the Hoboken Public Library one day, the air was filled with other tongues— Spanish, Italian, German—along with English, and with the laughter and delightful squeals of children playing, which are the same in any language. With the fall of the World Trade Center, just across a short span of the harbor, the city had once again felt a great loss, yet it was managing to overcome this tragedy to rebound and be in the sunlight once again.

—*Joe Czachowski*

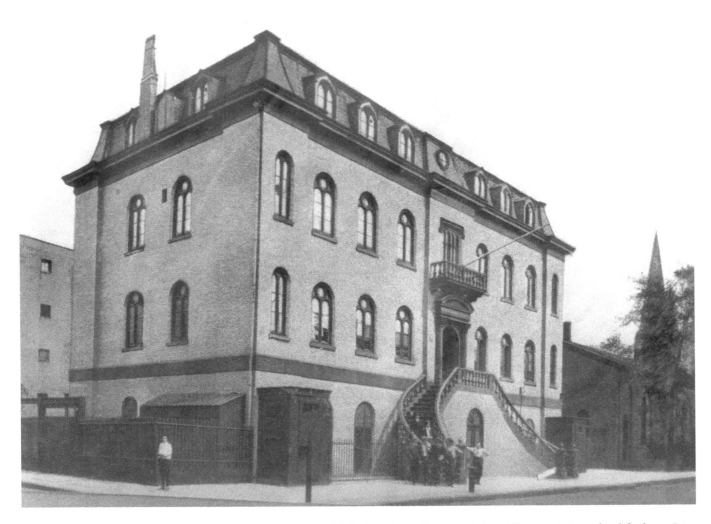

The Martha Institute at 6th Street and Park Avenue was established in the 1860s as an industrial-arts training school for boys. It later housed the Stanley Society, named for the well-known explorer Henry Morton Stanley and dedicated to the study of Africa.

HOBOKEN LAND AND IMPROVEMENT

(1860s–1899)

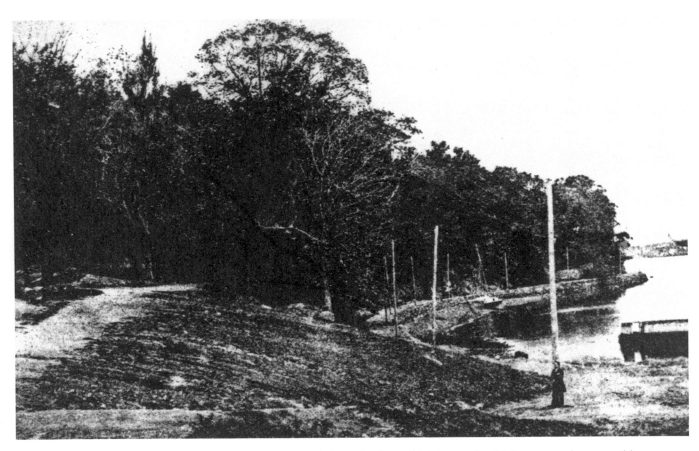

A person can be seen standing alone in this 1865 view north from the foot of 5th Street. Could that person have possibly imagined how this pastoral setting would be transformed in the years to come into a bustling port and manufacturing city?

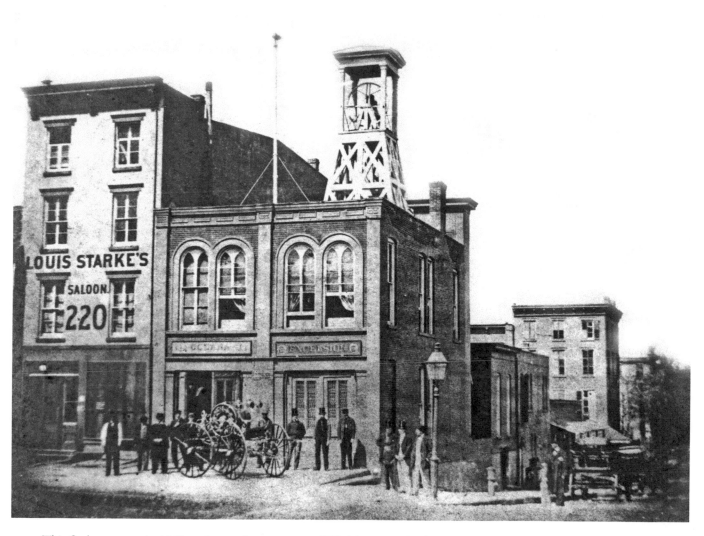

This firehouse seen in 1868 at the southwest corner of Washington and 6th streets probably housed Oceana Company No. 1 and Excelsior No. 2. A bell tower perches on the roof and Starke's Saloon is next door. Men in front are inspecting one of the fire wagons.

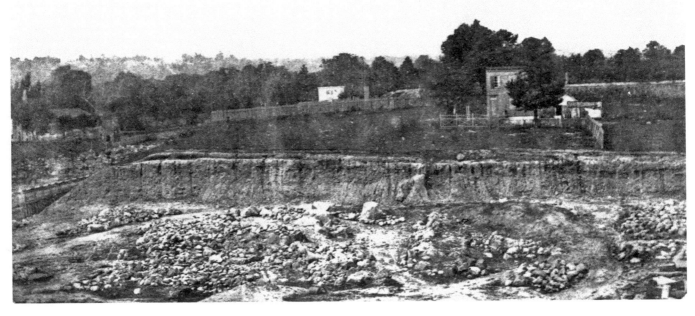

This view shows the site of Stevens Institute of Technology in 1868, two years before the school opened.

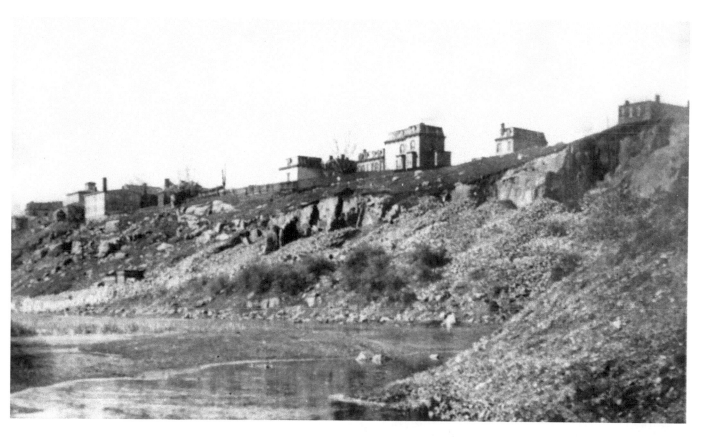

Shown here around 1870 is an area of Hoboken near where the Delaware, Lackawanna, and Western Railroad (DL&WRR) tunnel beneath the Hudson River would be completed. Samuel Rockwell, resident engineer of the DL&WRR, was responsible for the project.

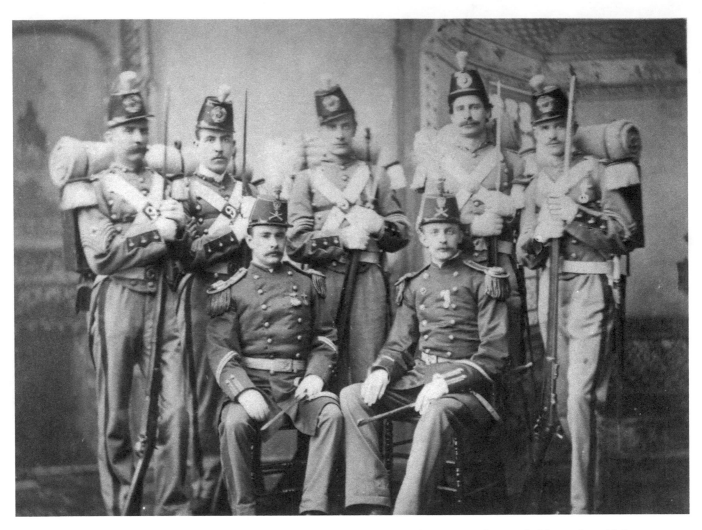

Hoboken war veterans in full uniform pose for a group photo around 1875. The men standing are holding rifles with bayonets, while the seated officers have riding crops.

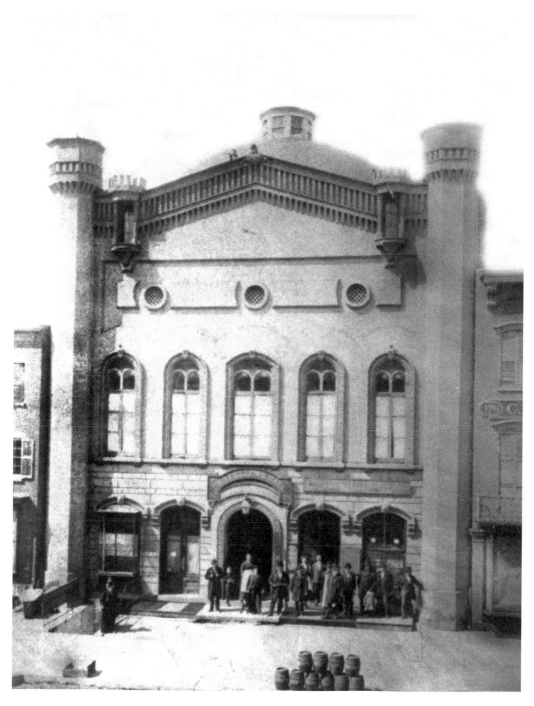

The Independent Order of Odd Fellows was established in England to give aid to those in need and to pursue projects for public good. The Hoboken Odd Fellows Hall, seen here around the 1870s, was located on Washington between 4th and 5th streets.

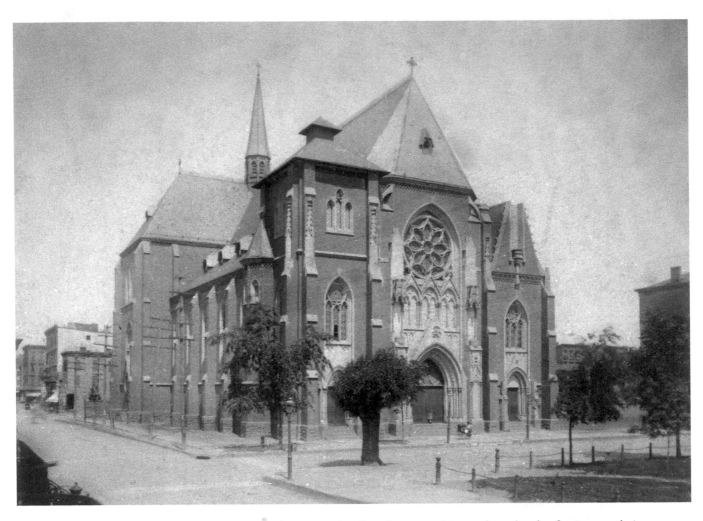

Our Lady of Grace Church was built in 1878 at 4th Street and Willow Avenue and is seen here shortly after its completion. Designed in the German Gothic style by Hoboken resident Francis George Hempler, it serves one of the oldest Catholic parishes in the United States. In its time it was the largest church in New Jersey, and it is now on the National Register of Historic Places.

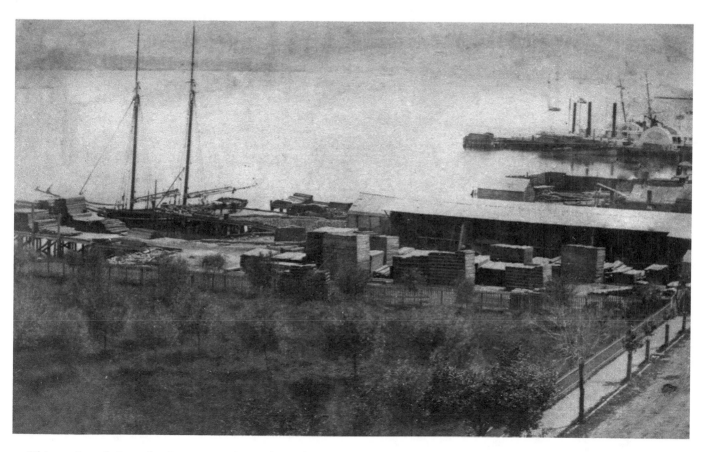

This southward view of a pier on River Street shows the harbor area beginning to take shape in the 1880s, with a few docks and ships and a lumberyard visible. The lumber was only construction material, but wood and sparks don't mix well, especially off the water. When boilers were put on the boats and ships, danger beckoned.

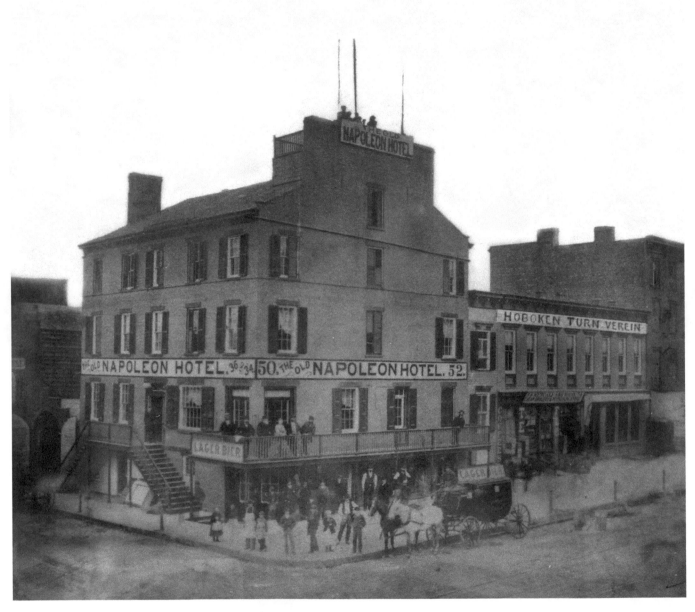

The Napoleon Hotel stood at 1st and Washington streets, with the Hoboken "Turn Verein," or German gymnasium, next door. This 1871 scene illustrates that photography was still a novelty—everyone seems to be facing the camera. People are even on the roof.

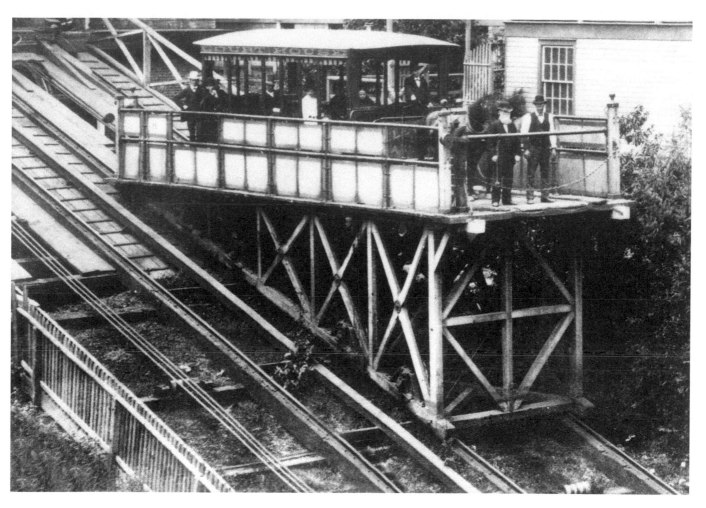

A horse-drawn trolley is transported by way of Hoboken's funicular in 1874. The funicular is a fourteenth-century invention for going up an incline too steep for conventional rails. In the conventional system the steel wheels on steel track would not be able to maintain traction, so in the funicular system, a cable pulls one car up while another car going the opposite way provides a counterweight.

Trolley tracks fill the foreground in front of the
2nd Precinct Police Station at Willow Avenue
and 12th Street.

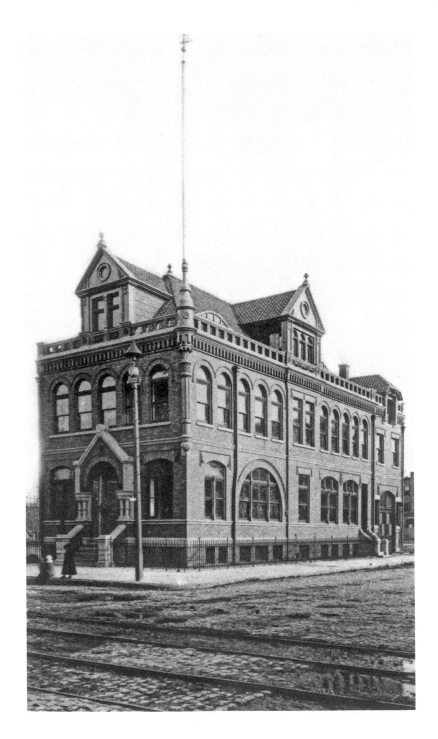

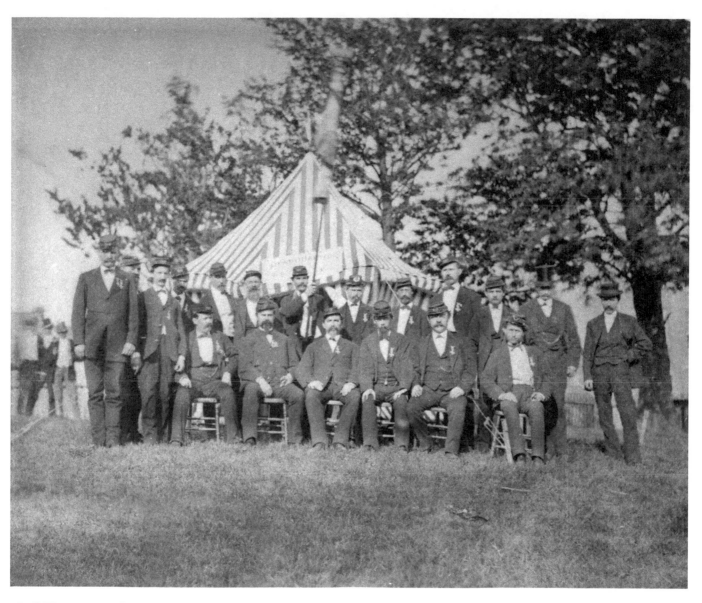

Civil War veterans of Hoboken gather in 1875 at the Otto Cottage Garden at Newark and 1st streets, probably commemorating a decade of peace.

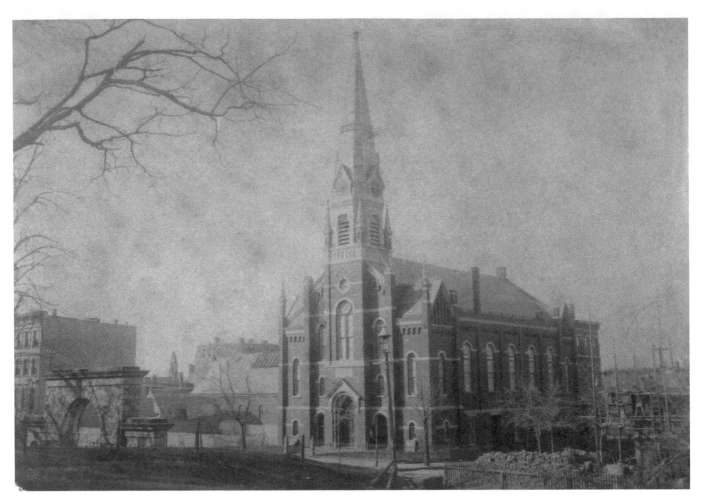

One of the oldest congregations in the city of Hoboken is that of St. Matthew's German Evangelical Lutheran Church at the corner of 8th and Hudson streets, seen here in the 1880s. Organized in 1858, the congregation occupied a former Presbyterian church before the current structure was completed. The towering steeple with its bell and clock rises to a height of 150 feet. The first pastor was C. M. Wassiddlo.

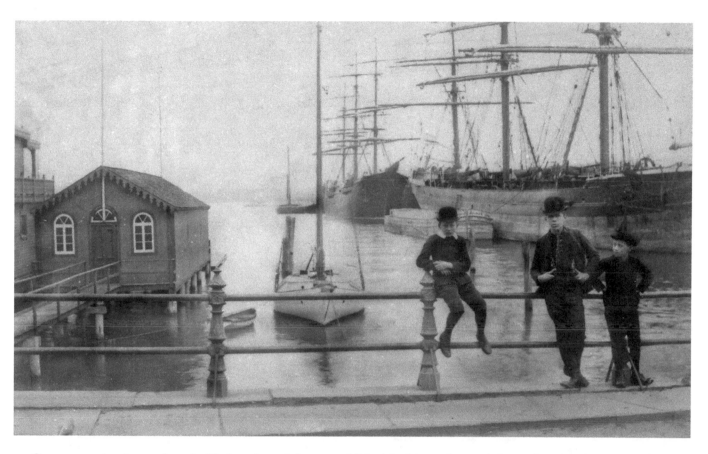

On an expansive river such as the Hudson, boat clubs are established for leisure-time yachting and rowing. Regattas and rowing meets become social events and tests of strength and skill, and heated rivalries develop. Here is the Germania Boat Club, located at the foot of 4th Street, in the 1880s. The mixture of commerce and pleasure is evident. Perhaps the three lads are waiting for the tide to turn.

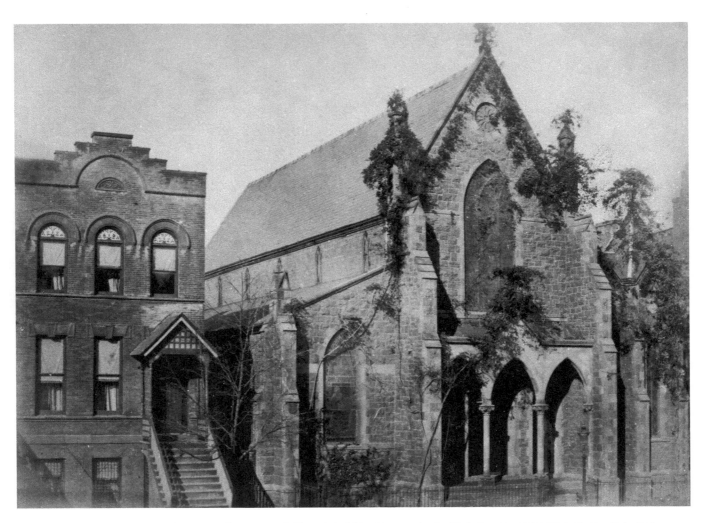

The congregation represented by St. Paul's Episcopal Church held its first service in Hoboken in 1832. This St. Paul's building, seen in the 1880s, was on Hudson Street between 8th and 9th streets. The first rector was John A. Wood.

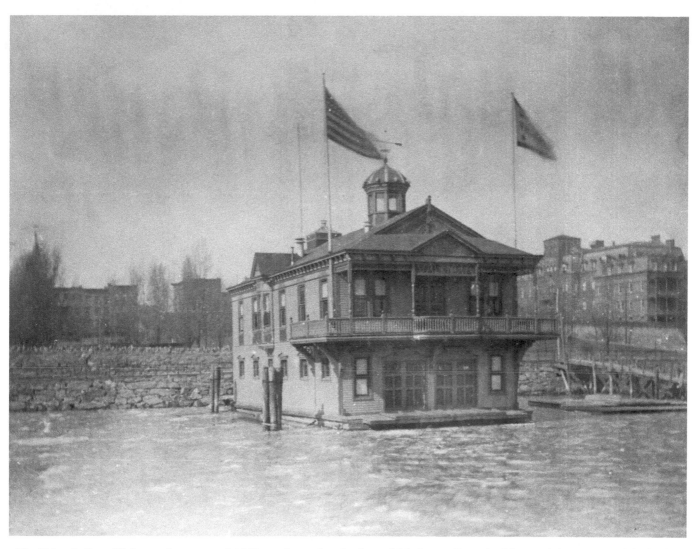

The Valencia Boat Club seen here around 1880 was located at the foot of 5th Street. Organized in 1874, it was one of the leading boat clubs along the Hoboken section of the Hudson River, and the club structure was considered one of the most handsome on either bank. The 100-member club had a reputation for social activities, as represented by a riding club, an orchestra, and a bowling team.

The Odd Fellows Hall, seen here around 1890, seems to have literally had its roof raised at some point in the preceding decade, with another floor added. The change is indicative of the growth in many aspects of Hoboken life.

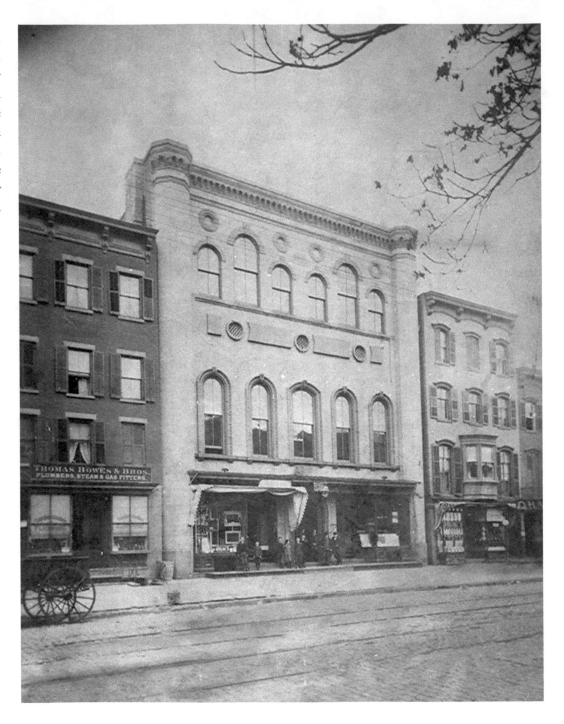

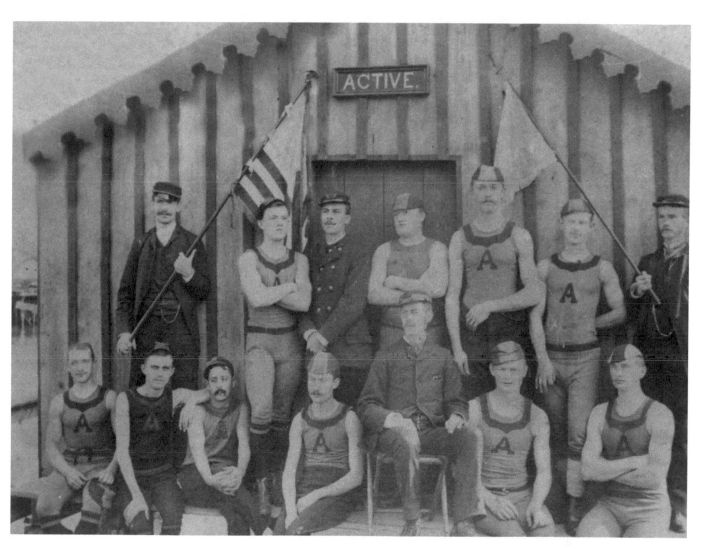

With so many Hoboken boating clubs established, such as the Active Boat Club seen here, as well as those in nearby New York, matches were always in vogue if the river wasn't frozen.

The Columbia Club, a "gentleman's society" of 100 men from Hoboken and New York City, was located at 11th and Bloomfield streets in Hoboken. This 1890s view shows the elegant style of architect Henry Hobson Richardson; the rounded archways and tower bespeak Richardson's interest in Romanesque style. The building was later the home of Euclid Masonic Lodge no. 35.

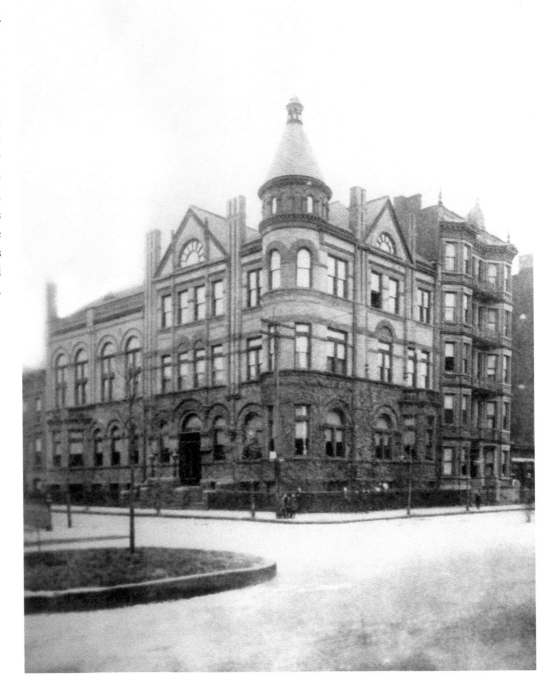

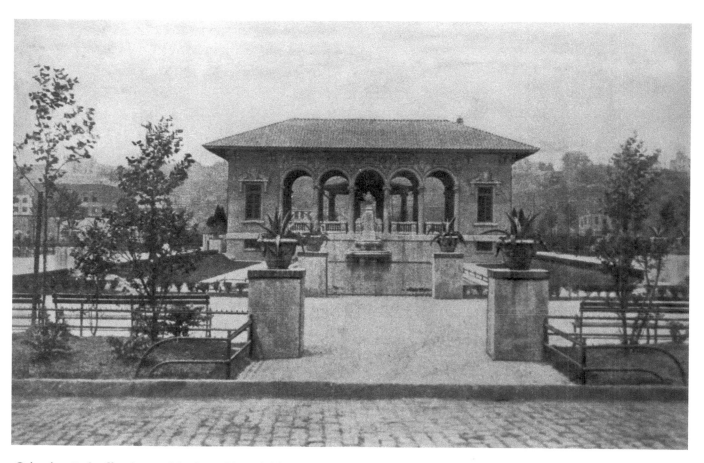

Columbus Park offered one of the first athletic fields in Hoboken, a city by then cramped for open space. This 1880s image shows a grand structure inviting visitors to escape from the city's crowded conditions.

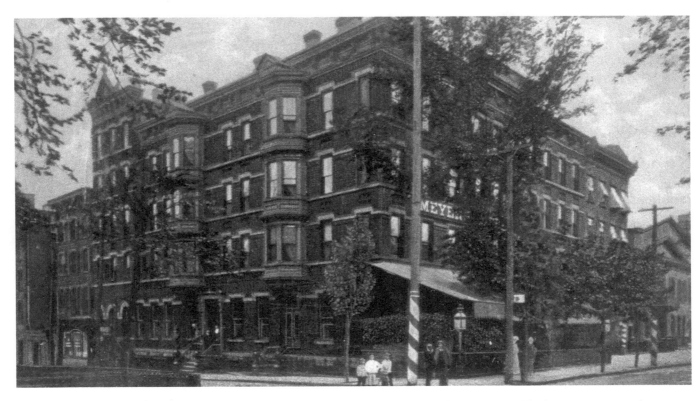

Meyers Hotel was located on the southeast corner of Hudson and 3rd streets. Built by Herman L. Timken, it was a popular meeting spot for community organizations and political clubs of all persuasions. Here the utility poles are adorned like candy canes for a festive occasion.

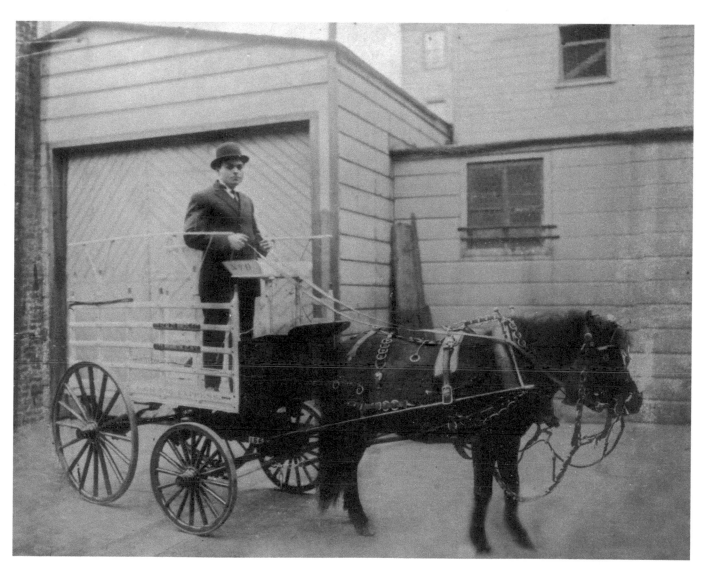

If you want to be a teamster you have to start somewhere, and Hoboken was a place where you could start small and dream big. Here the founder of the Gusto Trucking Company holds the reins, probably during the 1870s.

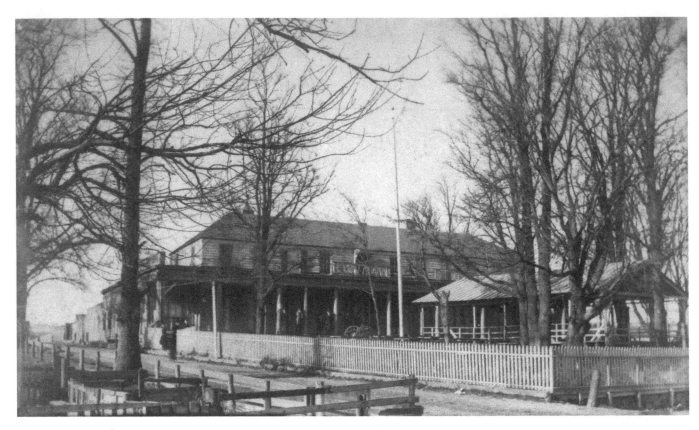

Seen here in the 1880s, the Colonnade House, known later as McCarty's Hotel, apparently was a popular spot for people to gather after baseball games and other sporting events played on the nearby Elysian Fields. There are numerous accounts of games being "replayed" into the wee hours of the morning over large glasses of lager.

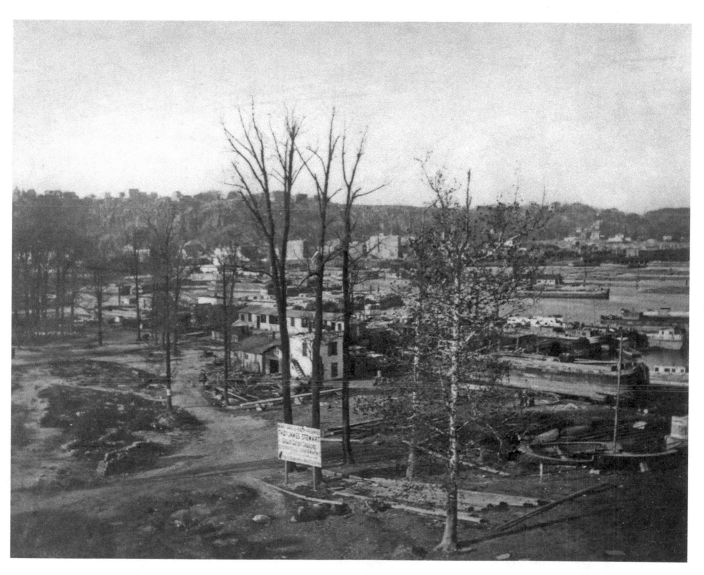

The Elysian Fields of Hoboken, seen here in the 1880s, had a significant role in the early years of organized baseball. With a limited amount of space in New York City, teams would often go to Hoboken to play. The first organized game was played at the Elysian Fields on June 19, 1846, between Alexander Cartwright's Knickerbockers and the New York Nine. Journalist Harry Chadwick promoted the use of the fields and became instrumental in the development of the national pastime.

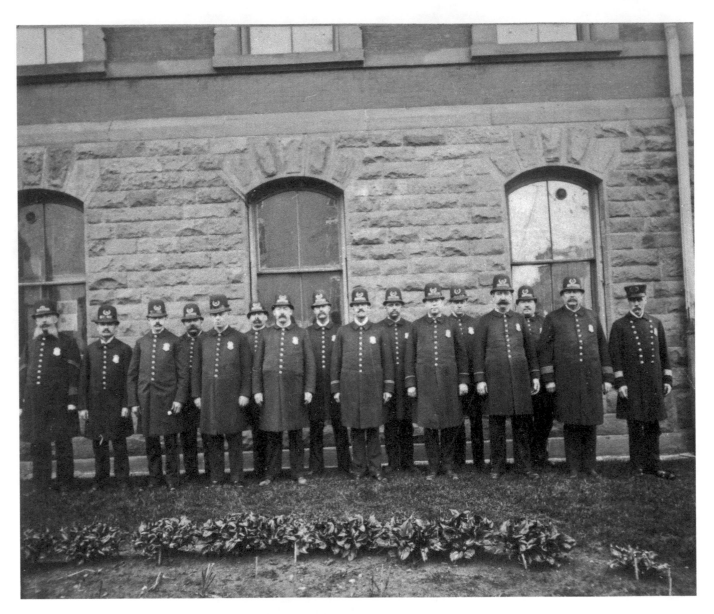

Members of the Hoboken police force pose next to a precinct house in the 1880s.

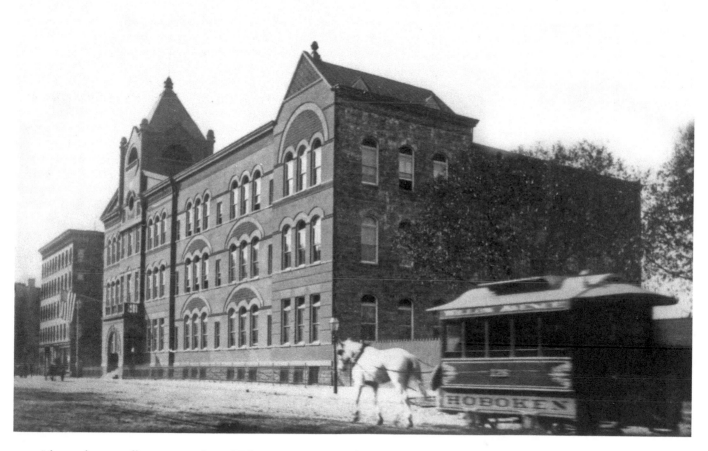

A horse-drawn trolley saunters down Willow Avenue near 11th Street. The aptly named Willow Avenue Line announced itself with signage on the side of the car.

On the corner of Newark and Washington streets stood Michael Coyle's Liquors and Tavern, seen here in the 1890s with the bartender and three others out front. Coyle was active in local politics, a good melding of business and pleasure. The Fabian Theatre later occupied this corner.

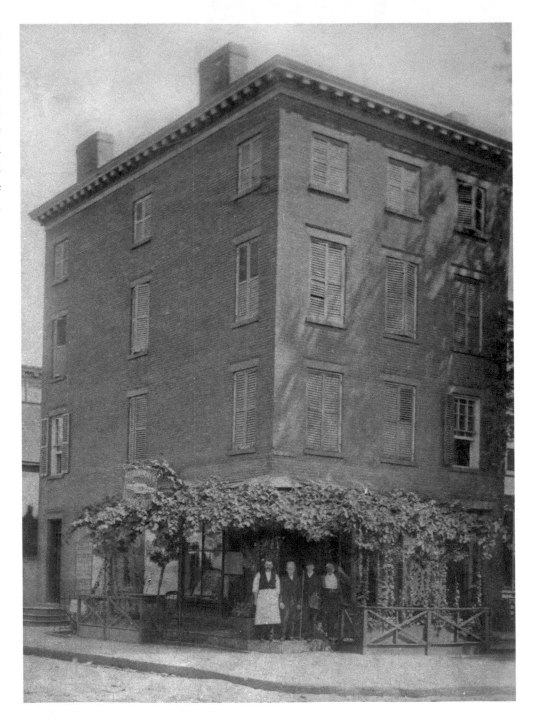

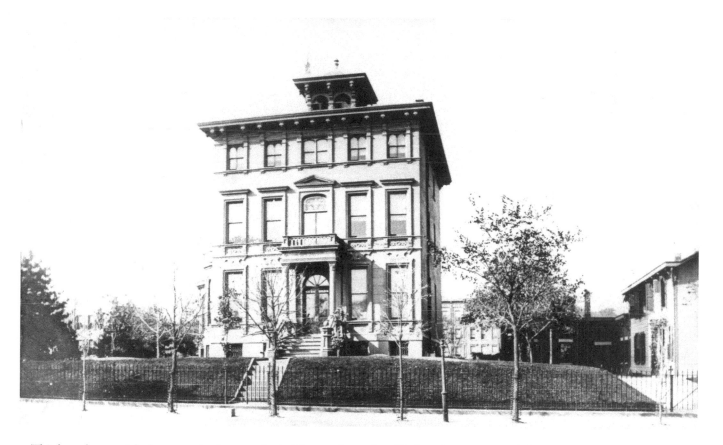

This large home with the expansive lawn on both sides was located on Hudson Street near 10th Street. Seen here in the 1880s, it was owned at different times by the Reiche family, the Crusius family, and later Lawrence Fagan, a Hoboken mayor and owner of the Fagan Ironworks that burned in 1905.

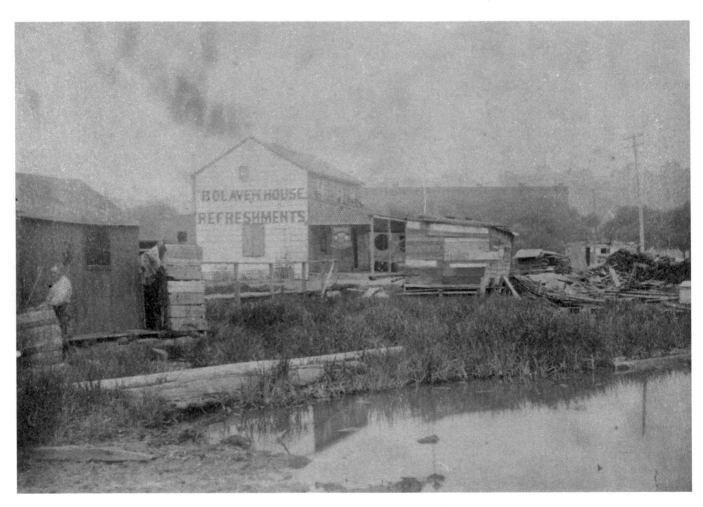

The Bolaver House at 11th Street and Park Avenue served refreshments to the workers in the area during the 1880s and 1890s.

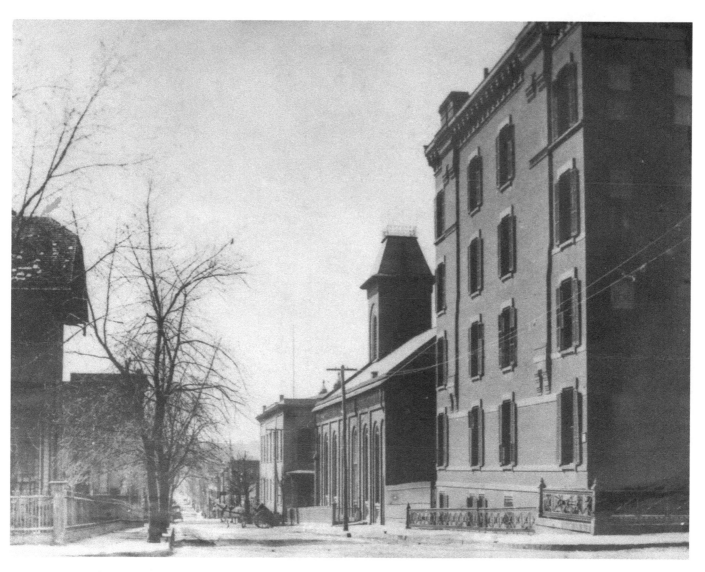

This 1880s view west from River and 6th streets includes the First Presbyterian Church located at 6th and Hudson.

Seen here in the latter years of the nineteenth century, Hoboken's Public School No. 1 was located on Garden Street near 3rd Street.

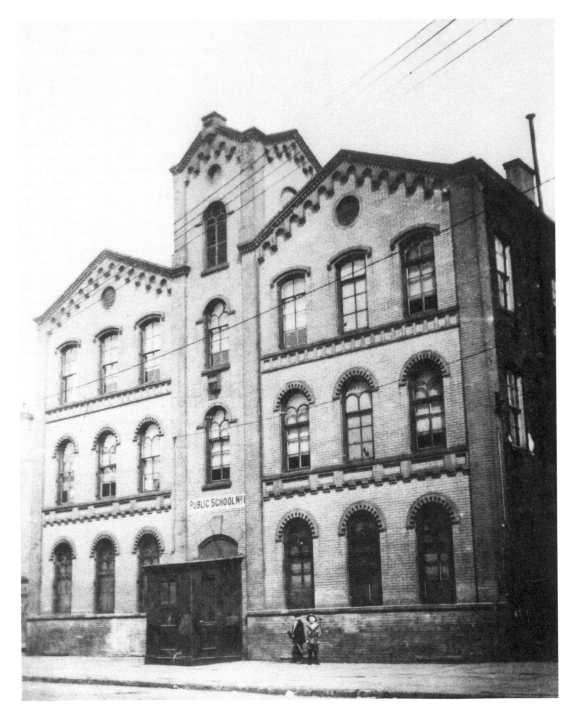

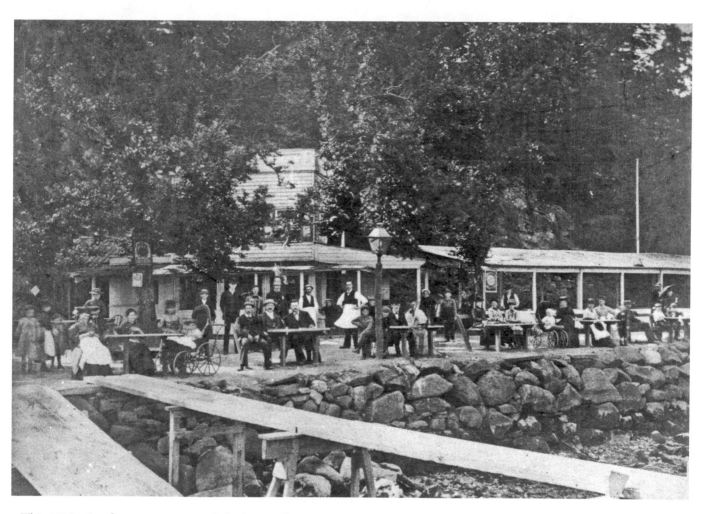

This 1890s view from a not-too-sturdy-looking walkway out toward the Hudson shows a leisurely scene near Sybil's Cave, a local attraction. Sightseers and tavern customers are enjoying themselves. Several baby strollers are notable for their very large wheels.

Henry Peters owned a grocery store at 223 Washington Street on the corner with 6th Street. In this 1880s scene, barrels are being moved by the staff. Perhaps a shipment of goods had just arrived in port from somewhere overseas.

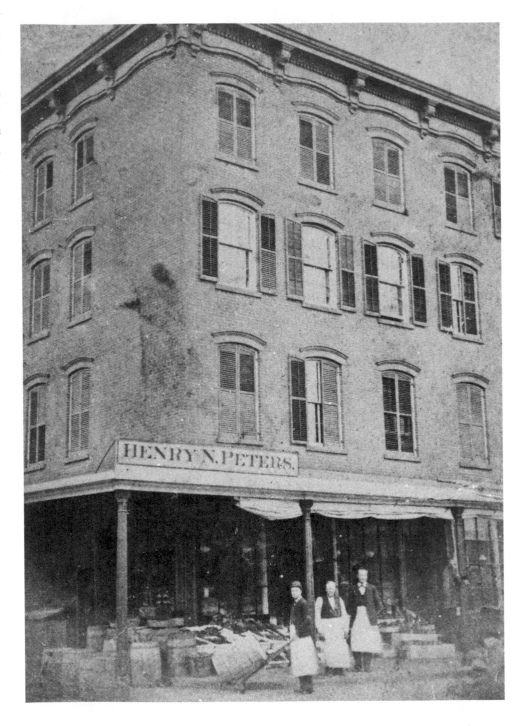

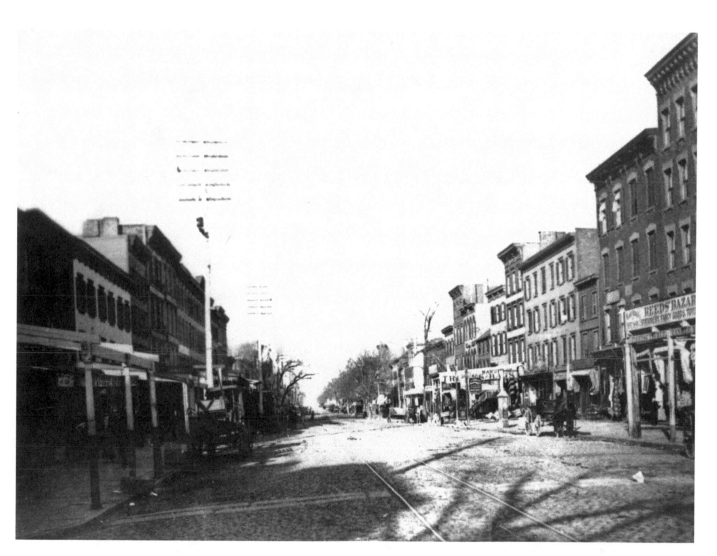

On the sunny side of Washington Street in 1885, an apparent calm prevails before shoppers arrive.

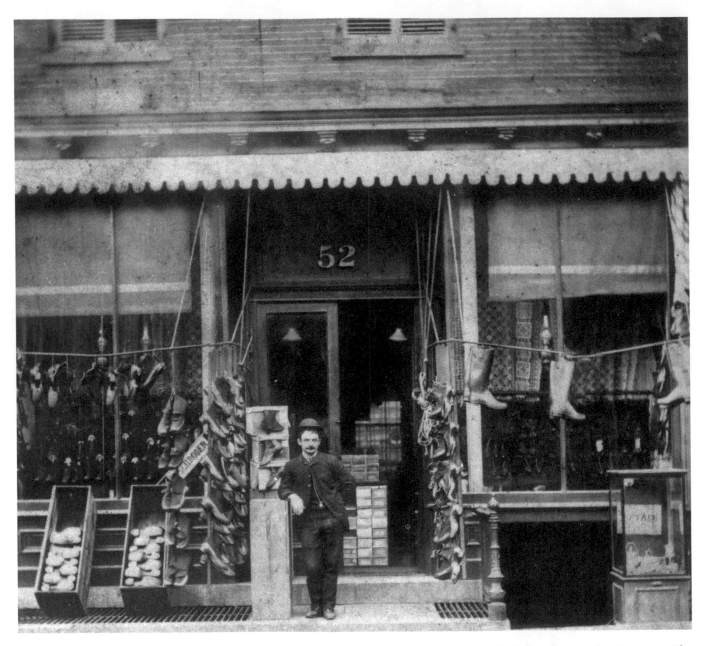

At 52 Washington Street stood William Schroeder's Shoe Store. Perhaps the man in front is Mr. Schroeder, guarding his wares. If so, he must have been hoping that customers would shrink his large inventory of boots and shoes of all kinds and sizes.

Above the intersection of Willow Avenue and 19th Street stood the Hoboken Toll Gate, which was the end of the Old Hackensack Plank Road. A plank road is as it sounds, a dirt road or path covered with wooden planks to facilitate travel.

Wiedermann's Groceries at 148 Washington Street did a profitable business in butter, tea, flour, "specialties," and "fancy groceries." In 1885 one might even have them delivered by wagon. Louis Wiedermann was the proprietor for 37 years, and his store was one of the largest in Hudson County. That could be Wiedermann and his son William in front.

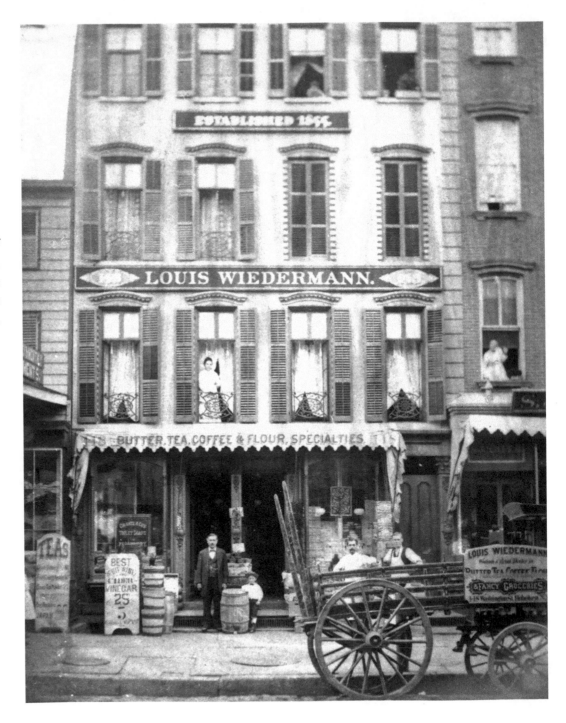

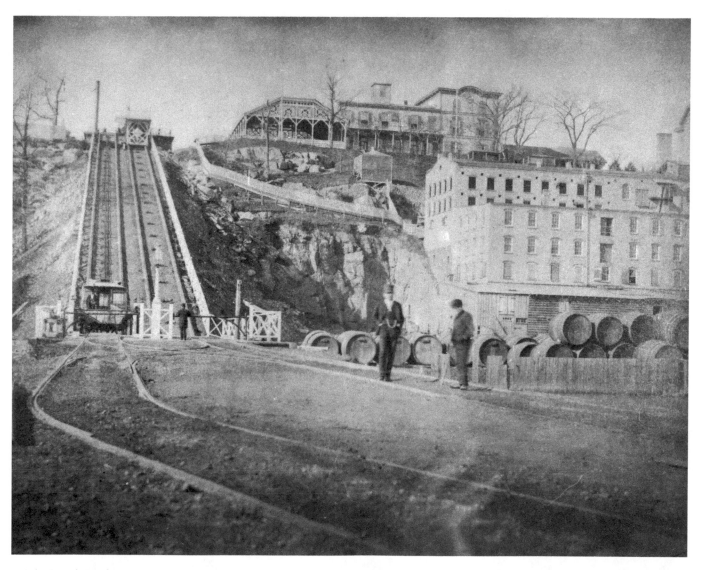

The North Hudson County Railroad Elevator rose from the foot of Ferry Street up to Jersey City Heights. In this view from the 1870s, shortly after the elevator was built, warehouses stand at the top and bottom with goods stacked and waiting for delivery. Also in view is the horse car and conductor. The elevator was taken apart in 1928.

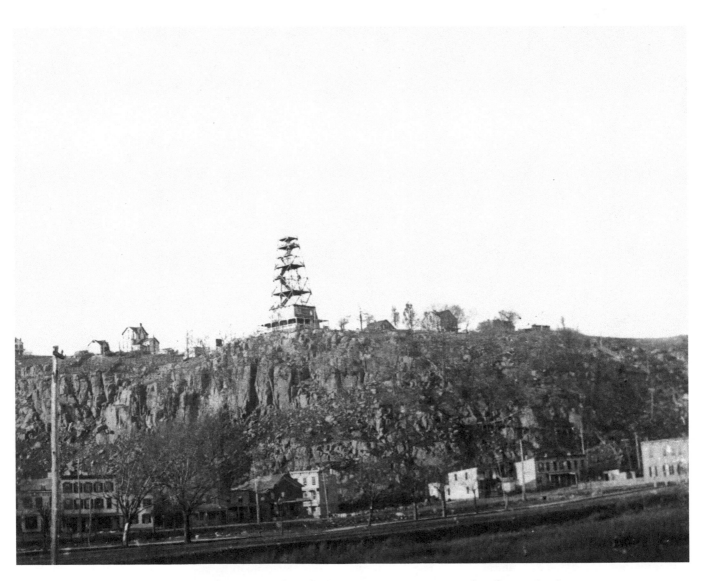

Seen in 1886, this observatory on Castle Point may have had some connection to research at Stevens Institute.

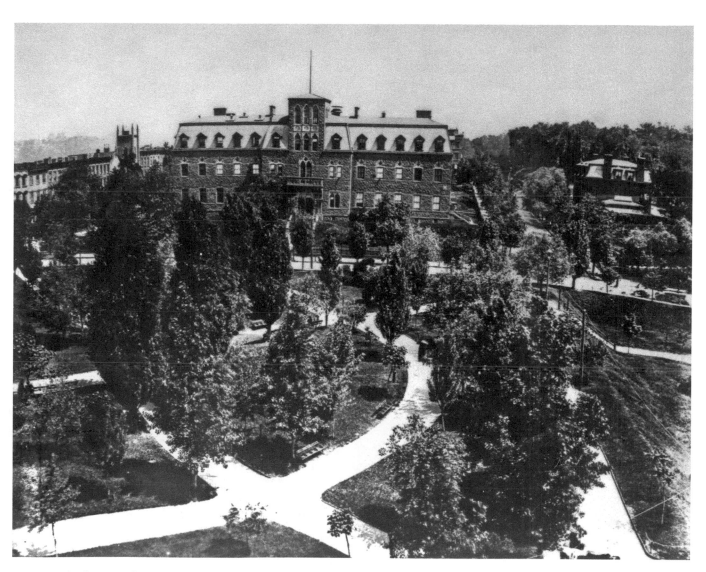

As seen looking north across Hudson Square Park in 1886, the Stevens Institute Administration Building is an imposing edifice, perhaps signifying that education is a solid building block for a student's future.

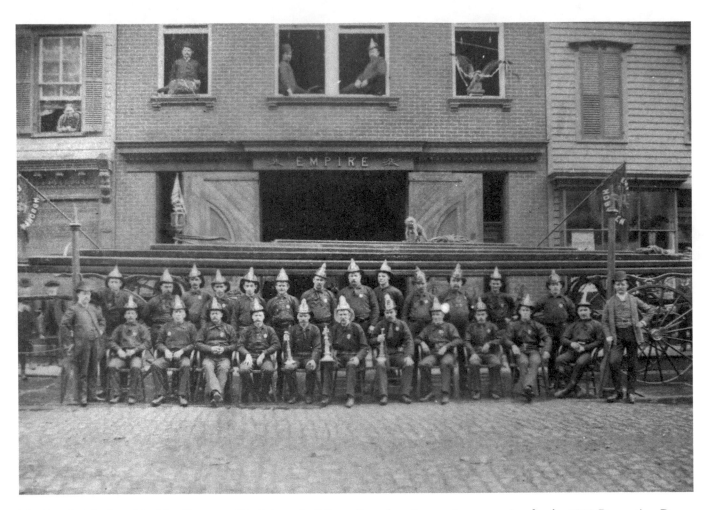

The Empire Hook and Ladder Company No. 2 is out in full regalia and equipment in preparation for the 1888 Decoration Day Parade. The fire house was located on 1st Street near Jefferson Street. Notable are the additional members in the windows and the monkey mascot.

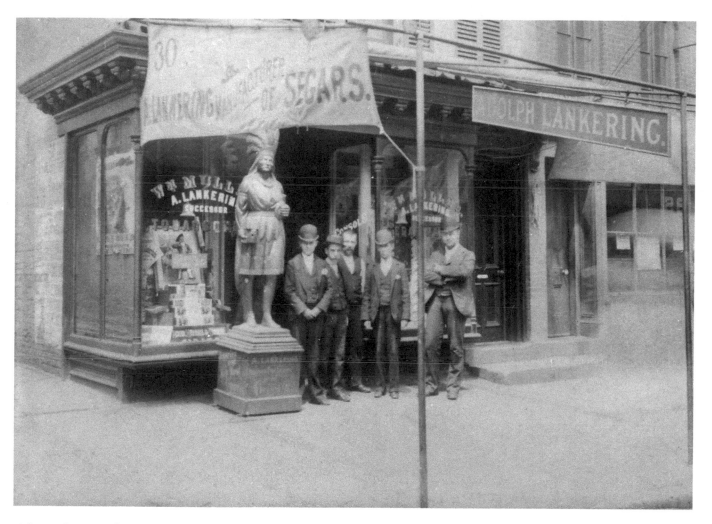

A "manufacturer of segars," Adolph Lankering operated the Hoboken cigar store seen here in 1887 at 30 Newark Street. After first entering the tobacco leaf business in Chicago in 1875, Lankering went east and started a cigar enterprise in Hoboken with his brothers George and Fred. He was elected mayor in 1902, and as a staunch supporter of Governor Woodrow Wilson he was later rewarded with the job of postmaster of Hoboken.

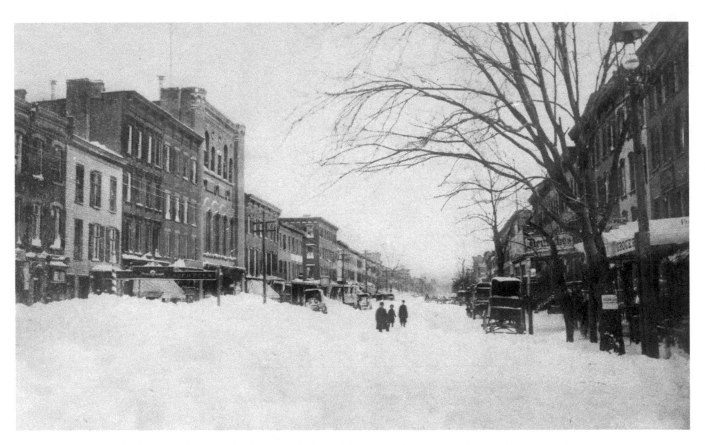

Snowdrifts are piled high on Washington, looking north from 4th Street, after a storm during the winter of 1888.

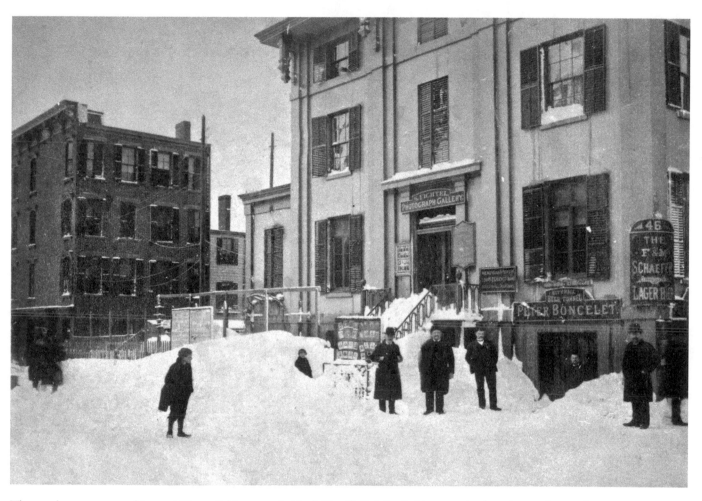

The southwest corner of 1st and Bloomfield streets, behind City Hall, is buried in snow in the winter of 1888, but one can still see a photo gallery and a bar advertising lager beer.

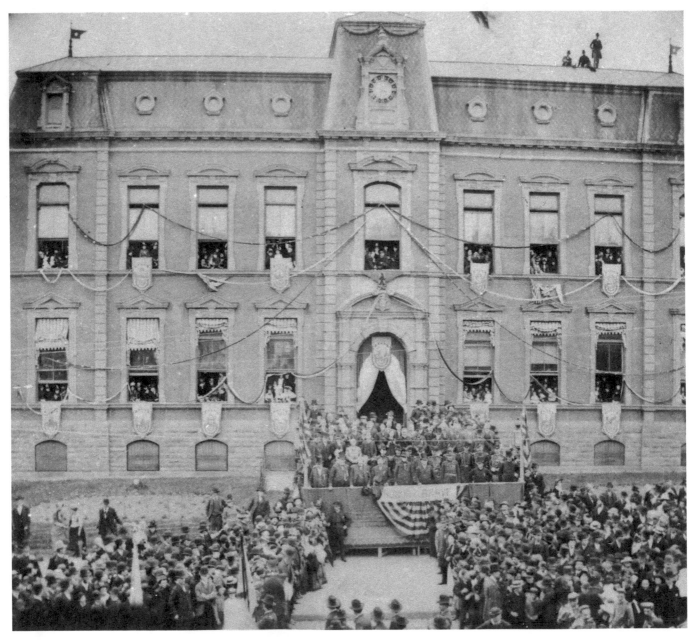

Mayor August Grassman speaks to a large crowd in front of City Hall during a ceremony feting police and fire personnel in 1889. The banner in front has the words "Honor" and "Brave."

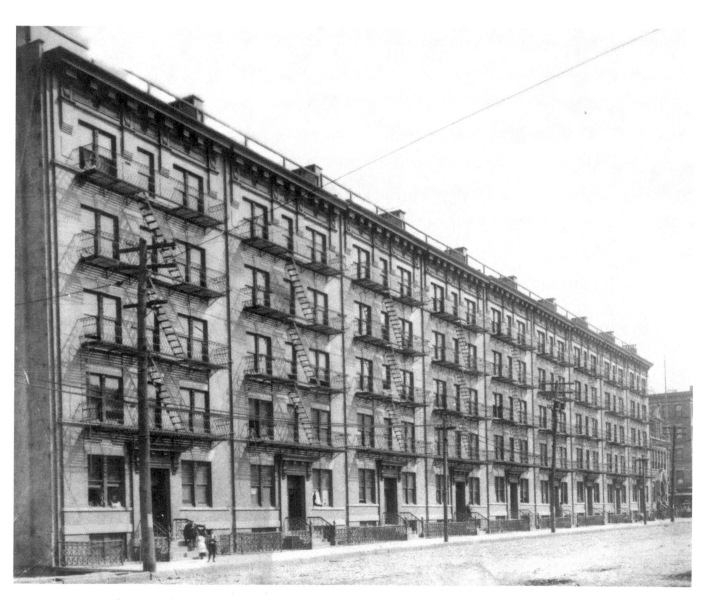

Space was at a premium in 1890s Hoboken, as is illustrated by this photo of Willow Avenue apartment houses.

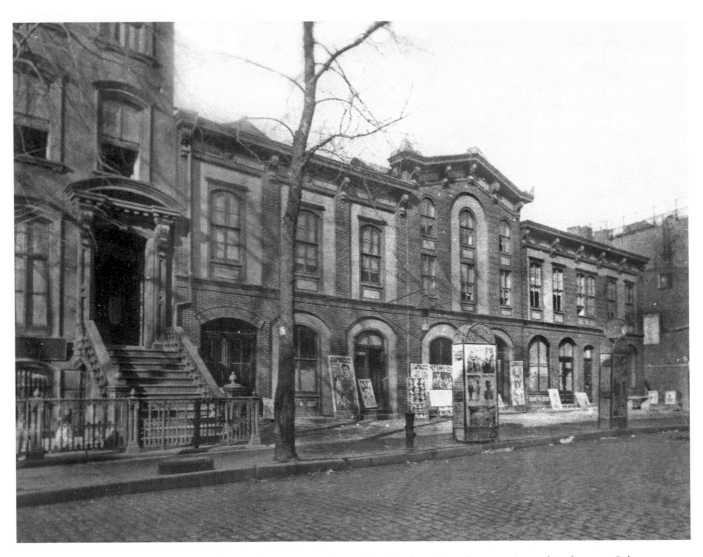

The Germania Garden Theatre shown here in the 1890s was located on Hudson Street between 1st and 2nd streets. It later became the Rialto Theatre. European-style marquees are visible near the curb.

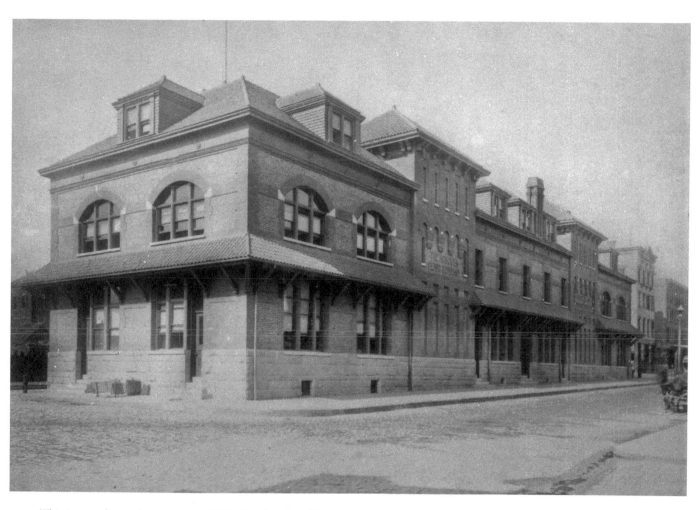

This image shows the rear of the Hoboken Land and Improvement Company in 1890. The company was a private agency in charge of doling out parcels of land in the city for building purposes.

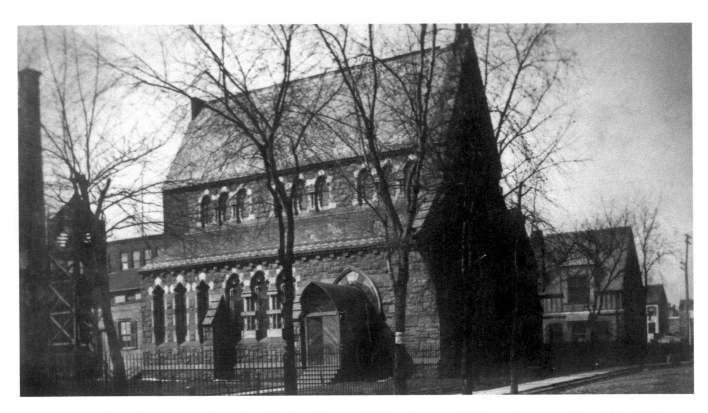

The Church of the Holy Innocents, located on 6th Street between Willow Avenue and Clinton Street, was founded in 1874. Designed by N. V. Halsey Wood, it was endowed by Martha B. Stevens as a memorial to her daughter Julia. The first priest in charge was Henry F. Hartman; the first rector was C. C. Parsons. The church initially had no pews, just chairs.

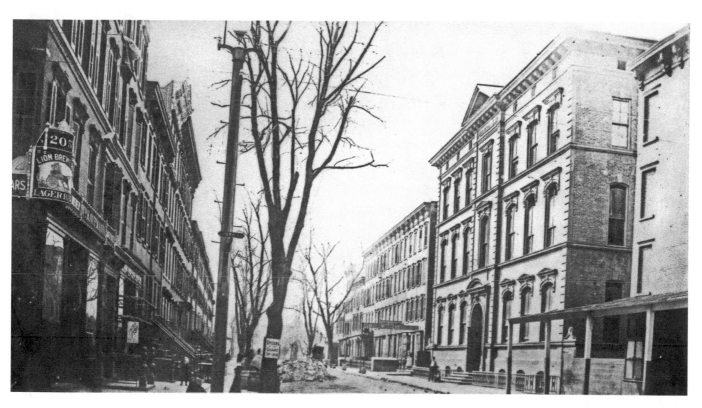

School No. 4 on Park Avenue, at right, is shown here around 1892. It was located near an establishment dispensing lager.

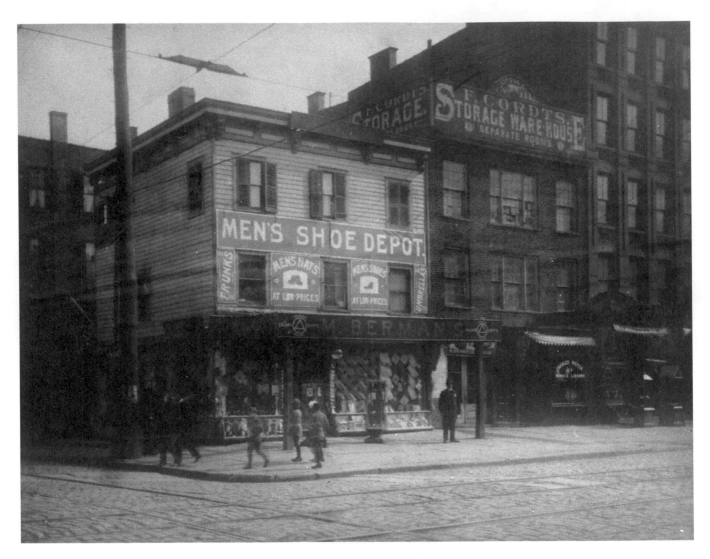

The Men's Shoe Depot, apparently run by M. Berman, was located at 135 Washington Street in 1893. Cordt's Storage Warehouse next door doesn't appear to be much larger than Berman's. The large sidewalk has some foot traffic and is patrolled by the policeman on the beat.

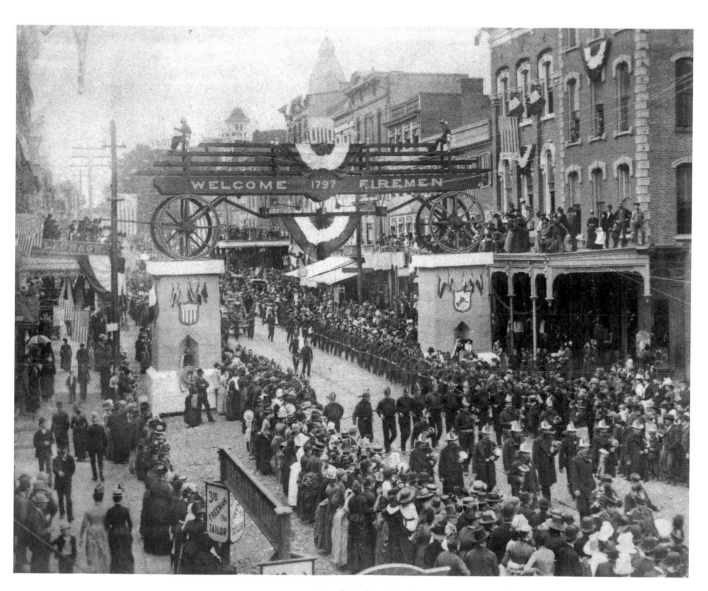

The Hoboken Fire Department marches in an 1897 out-of-town parade.

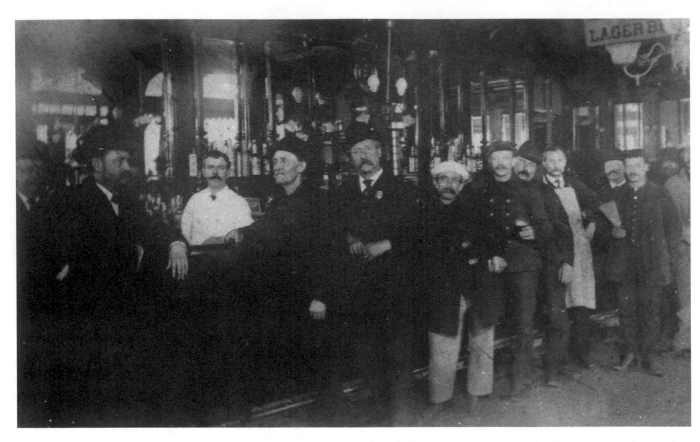

A group known as L. C. Philibert's Spanish War Veterans indulge and probably swap war stories at a local tavern around 1899. Philibert was a drum major who had his own local drum corps prior to the Spanish-American War.

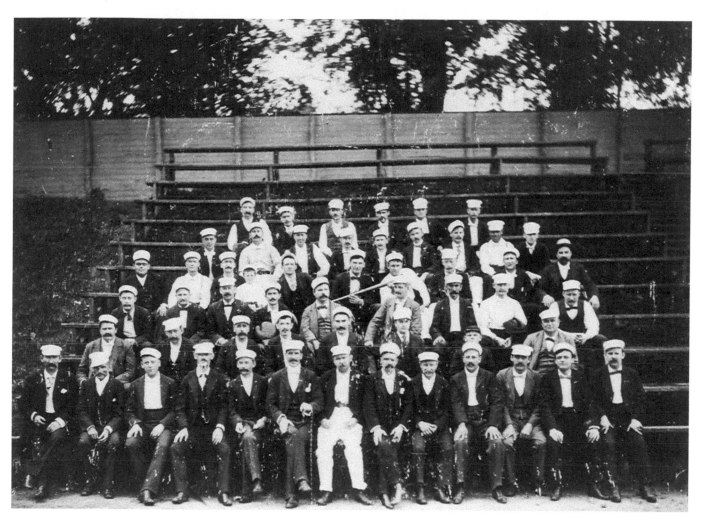

The Pioneer Bowling Association poses outdoors in Hoboken on August 1, 1897. The Dutch and Germans played the game of "ninepins" enthusiastically and brought it with them to the United States.

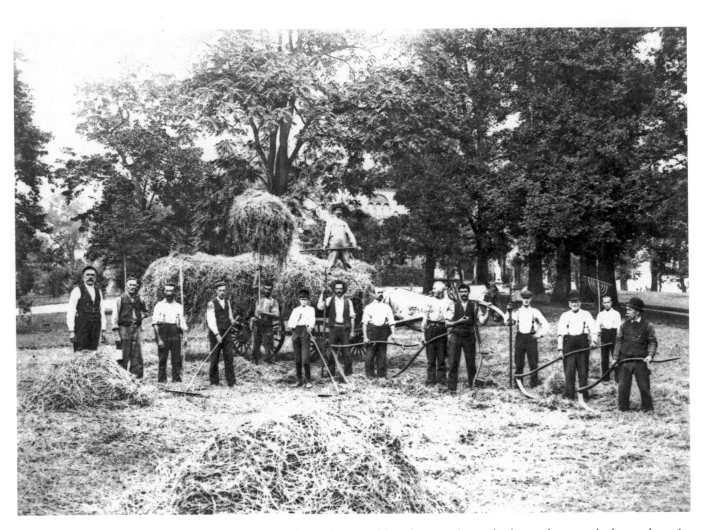

On the Stevens Estate in 1898, workers harvest hay. The workers would use large scythes and other tools to cut the hay and toss it up onto the horse-drawn wagon.

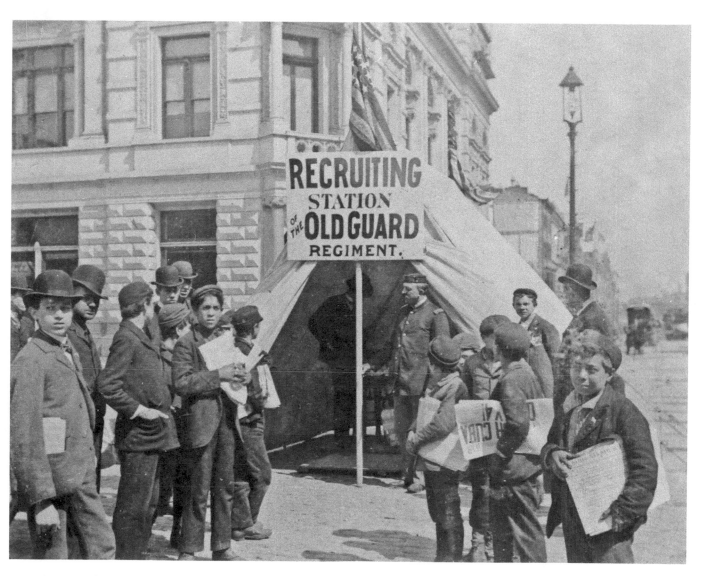

In this scene from the time of the Spanish-American War, newsboys hawk the day's papers in front of a recruiting tent set up for enlisting Hoboken men into the Old Guard Regiment. An officer is out front to welcome volunteers.

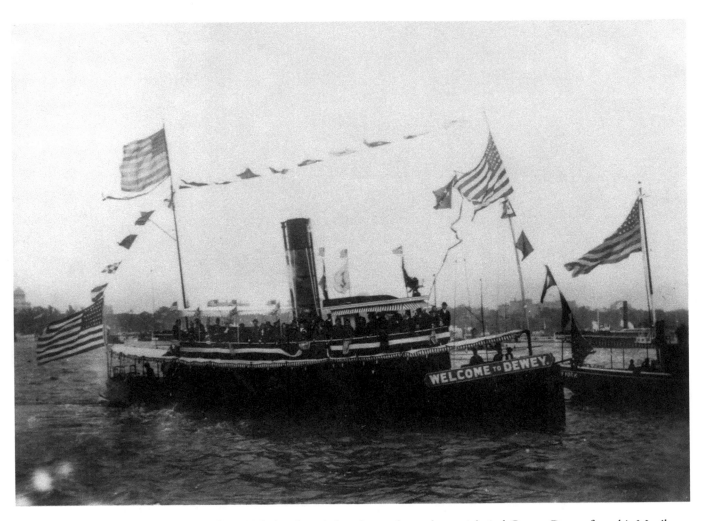

On September 30, 1899, a contingent from Hoboken boarded craft to welcome home Admiral George Dewey from his Manila campaign during the Spanish-American War. Flags flap wildly in the breeze. This was also the occasion of the first Marconi wireless broadcast for commercial purposes in America, reaching from out at sea to Sandy Hook, New Jersey, and on to the New York City papers.

Port City in a New Century

(1900–1929)

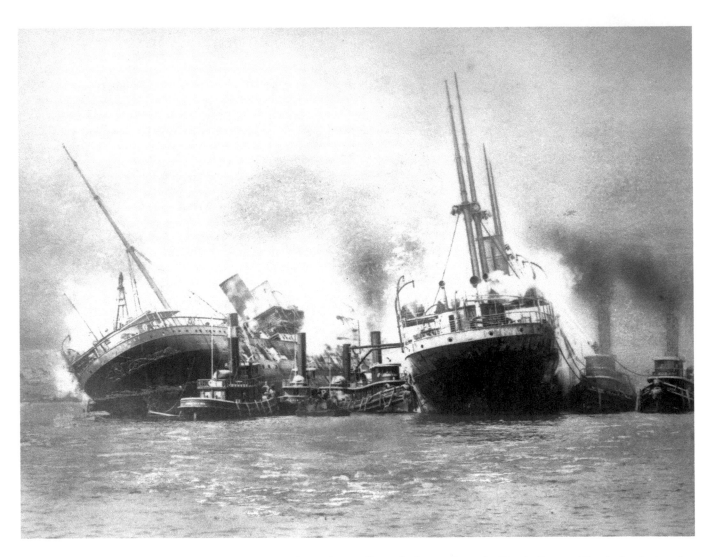

The burning steamships SS *Bremen* and SS *Main* are being frantically pushed away from the North German Lloyd pier during the fire of June 30, 1900. The cause of the fire was never established. Also damaged were the *Kaiser Wilhelm der Grosse* and the *Saale*. The scene was chaotic, with wind-driven flames burning ropes and setting the ships adrift, and tugboats scrambling to stop them for fear of the fire spreading beyond the adjacent piers.

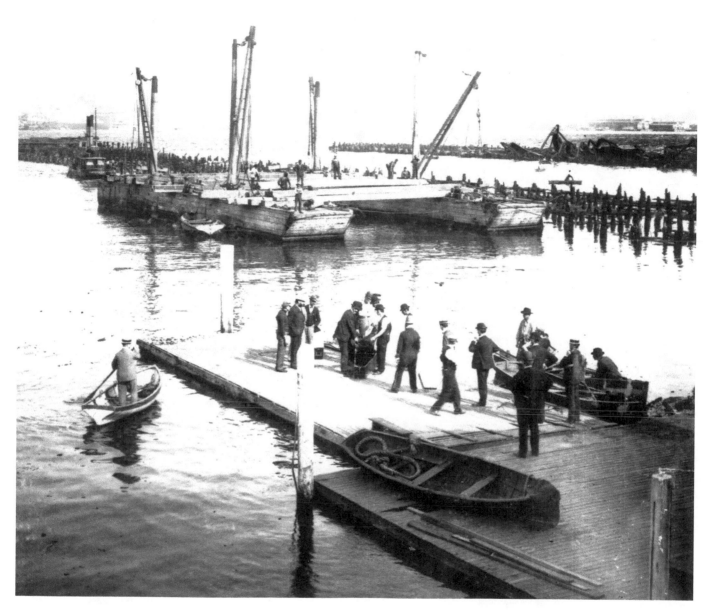

Close to 400 people died in the Hoboken dock fire of June 30, 1900. The hulks of the damaged ships glowed red into the night after the fire was out. Here men search for bodies of those who perished. The excavation of the ships, as part of the search, became the mission of many volunteers. In an amazing bit of good luck, some survivors were found and pulled out alive, having been trapped in safe pockets shielded from the flames.

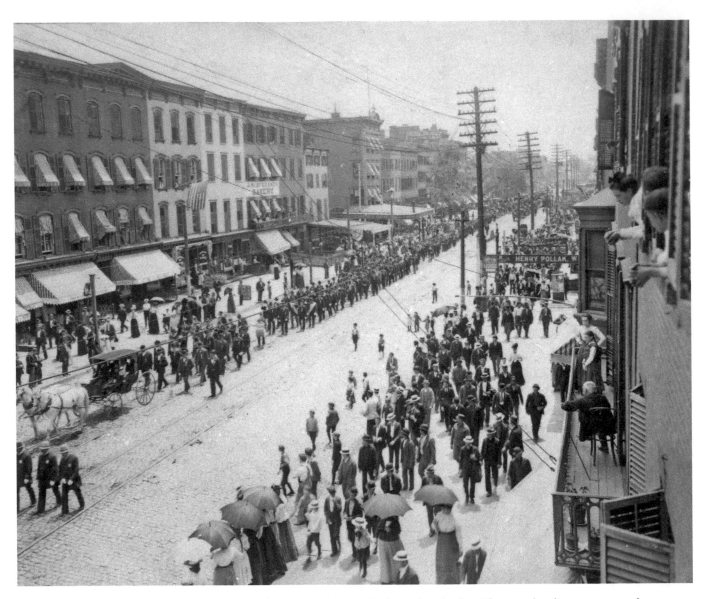

Onlookers on Washington Street watch a funeral procession that took place after the fire. This was the climax to a tumultuous few days. More than one million people in the surrounding area witnessed the fire, which was documented by photographers and journalists alike. The North German Lloyd line was not just an employer in Hoboken; its sailors and workmen availed themselves of the local German population and endeared themselves to the community. The loss was tragic. The line, which still operates, is known today as the Hapag/Lloyd Line.

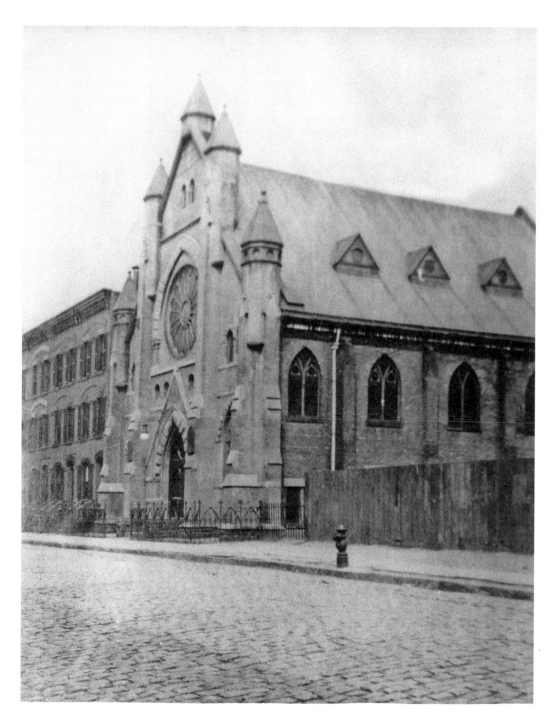

This is an early 1900s photo of the First Dutch Reformed Church on Bloomfield Street.

This grand structure housed Hoboken Engine Company No. 2 at 1313 Washington Street. The building still stands and is still home to an active engine company. Ladder Company No. 1 has been added.

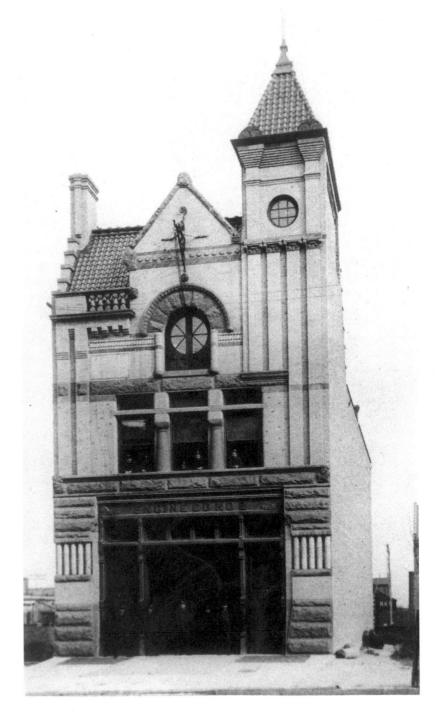

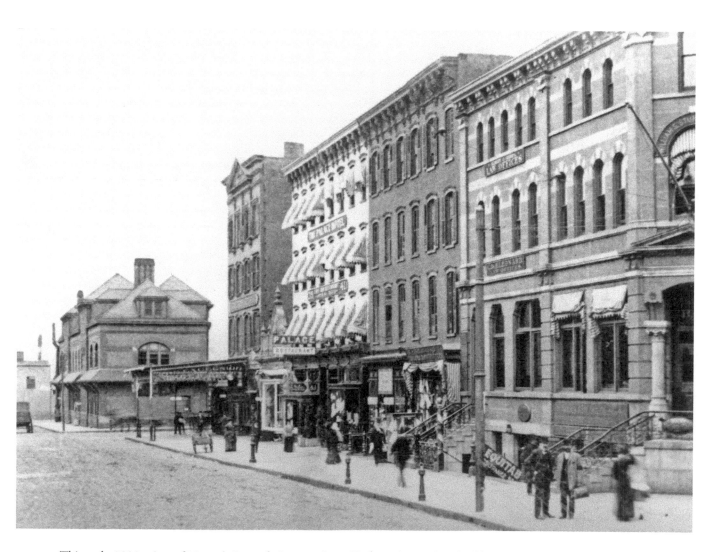

This early 1900s view of Newark Street facing east from Hudson shows close buildings and basement-level businesses. The Hoboken First Bank on the corner was torn down in 1912 to be replaced by another bank.

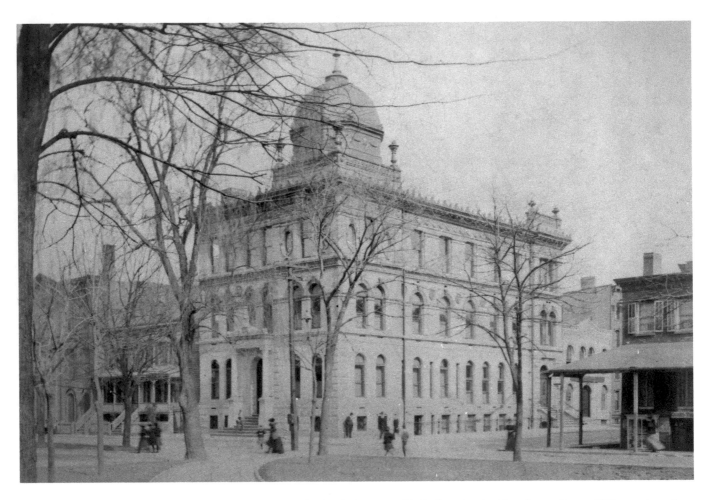

The Hoboken Public Library at 500 Park Avenue was the third library established under the New Jersey General Library Act of 1894, following those of Paterson and Newark. The cornerstone was laid April 14, 1896, and the library opened its doors on April 5, 1897. Seen here a few years after opening, it is still in operation at the same location.

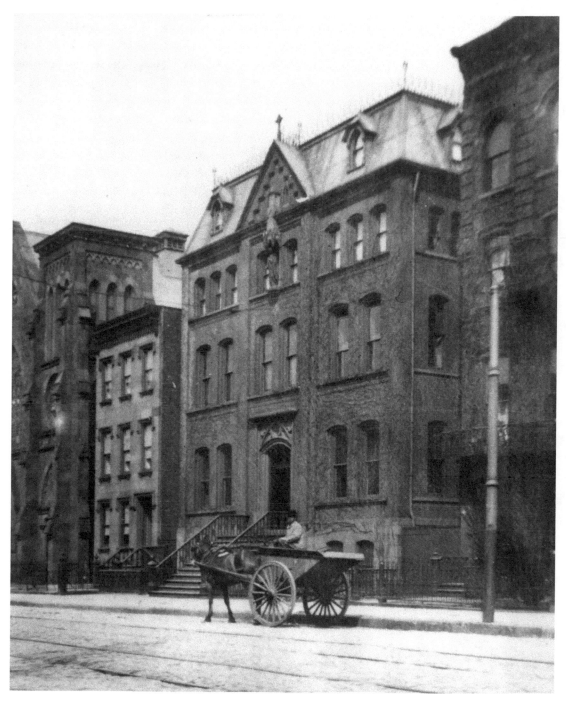

Sacred Heart Academy, located at 713 Washington Street, is a Catholic school for young women administered by the Sisters of Charity of St. Elizabeth. Seen here around 1900, it opened in 1868 and is still in operation.

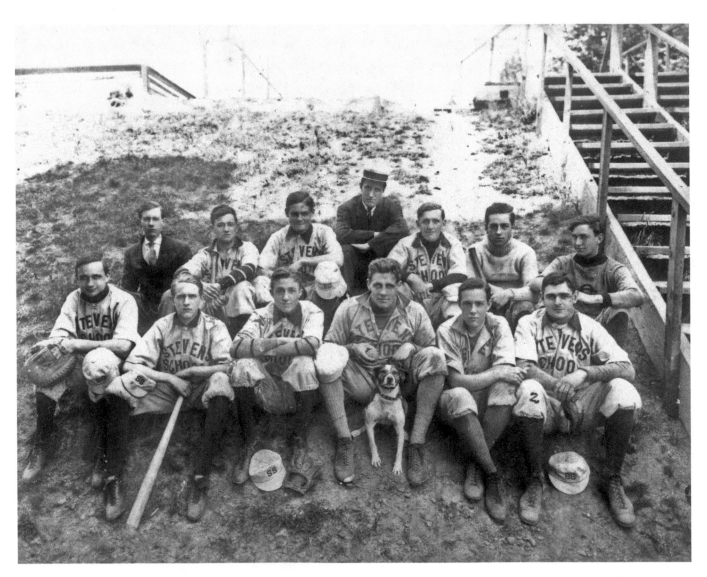

Stevens School was located on the Stevens Institute of Technology campus. This early 1900s photo shows the school baseball team, including its canine mascot, near the Castle Point steps.

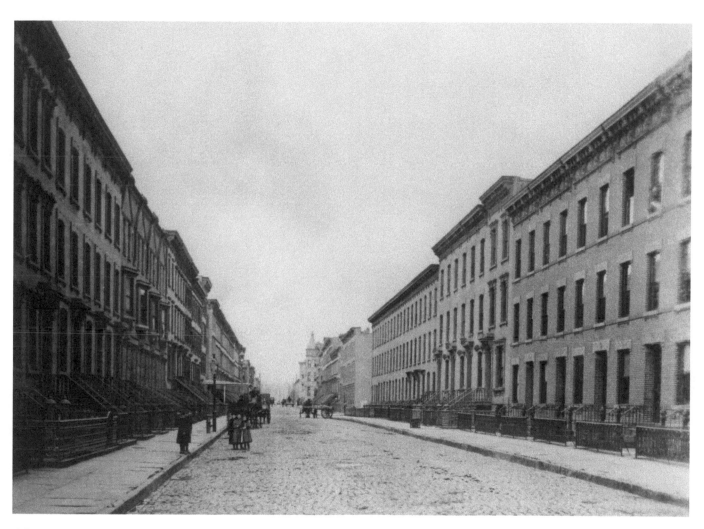

Three-story tenements are sandwiched together on cobblestoned Bloomfield Street between 9th and 10th in this early 1900s view.

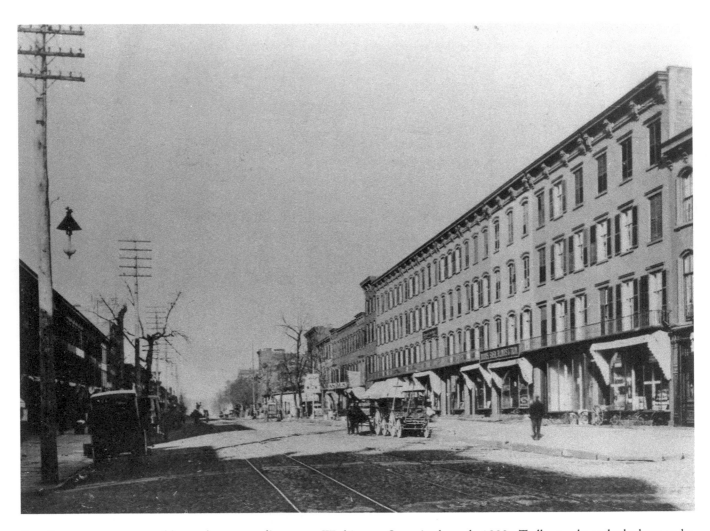

Storefronts, apartments, and horse-drawn carts line sunny Washington Street in the early 1900s. Trolley tracks and telephone poles signify a modernizing city.

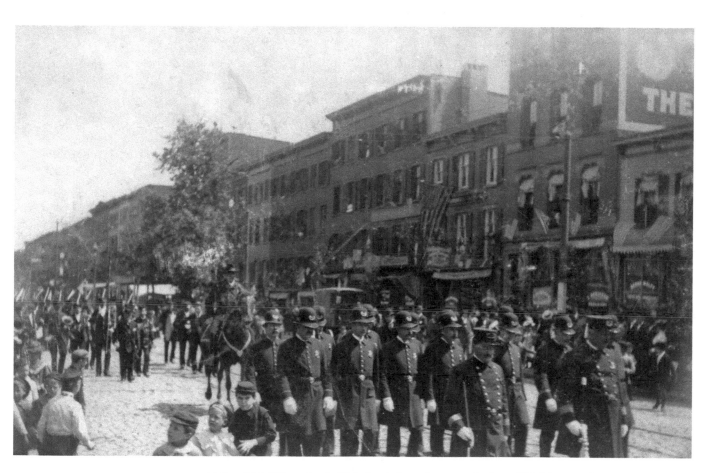

Police Chief Hayes leads Hoboken's finest in a parade down Washington Street around 1902.

The Castle, sometimes called Castle Stevens, was the residence of Edwin A. Stevens, founder and benefactor of Stevens Institute of Technology. Purchased by Colonel John Stevens and rebuilt in 1854, the house was turned over to the Stevens Institute on May 27, 1911. A year later it became a 45-room dormitory and meeting place for students. The building was demolished in 1959.

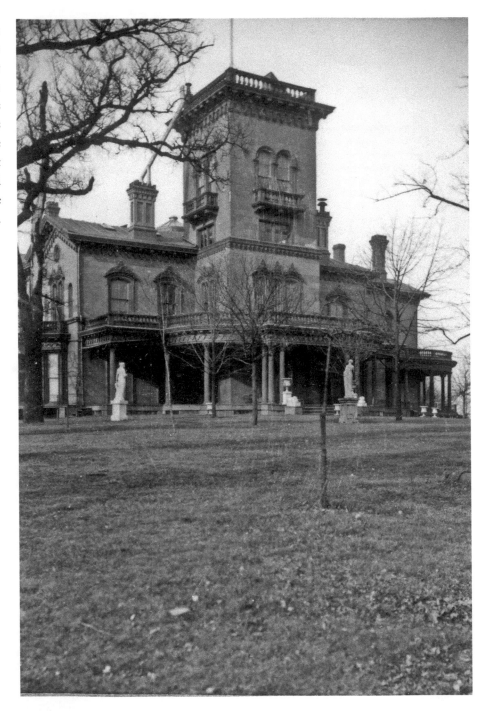

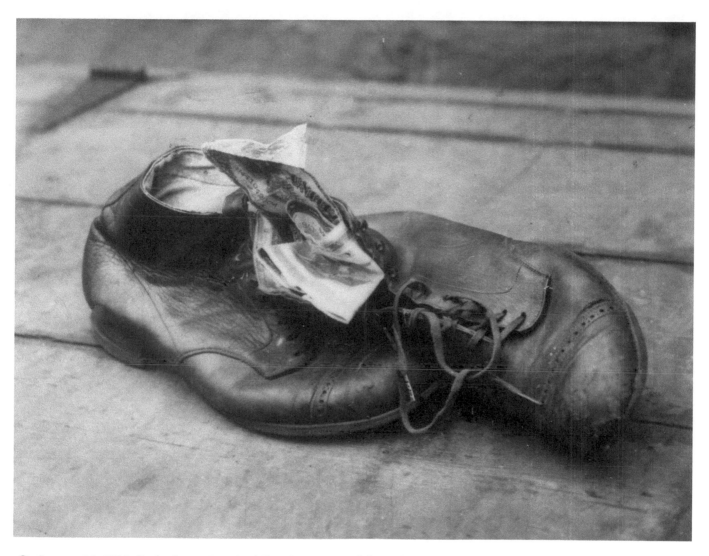

On January 30, 1905, fire broke out in a third-floor linen room of the Colonial Hotel at 59 Newark Street. Flames spread rapidly, and 12 people were killed. A man named Walters who had hidden money in his shoe was able to recover it at the police station. His $450 was still intact.

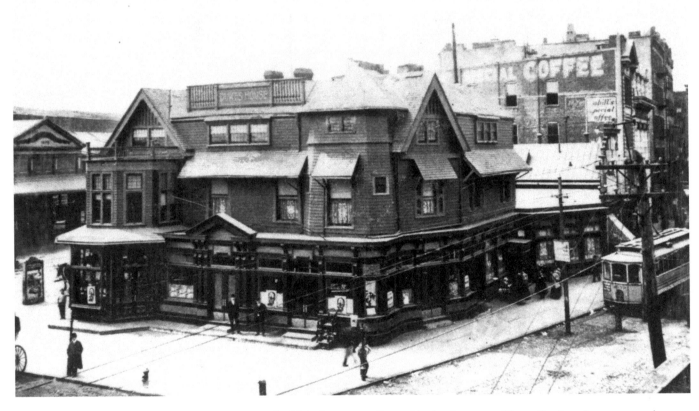

Dukes House was located on Newark Street near the Hoboken Ferry. Owned by businessman Henry Ranken, it was a noted tavern that drew clientele from boxer John L. Sullivan to millionaire William K. Vanderbilt. The tavern burned August 7, 1905, in a fire that started on the piers of the Delaware, Lackawanna, and Western Railroad a few blocks away. Four ferries were consumed in the flames, which spread to shacks, warehouses, and eventually Dukes.

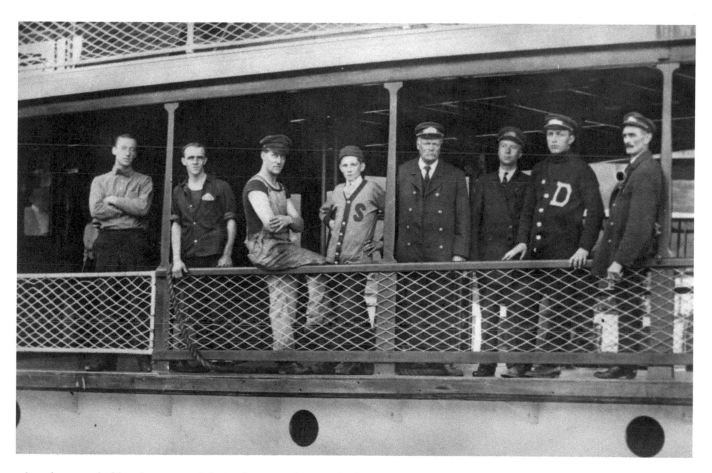

Seen here are deckhands on one of the Lackawanna ferries. The ferry terminal, built in 1907, extended over the water and had six ferry slips, and tracks for up to 14 trains. With business possibilities abounding after the turn of the century, the need for more ferries to New York was realized.

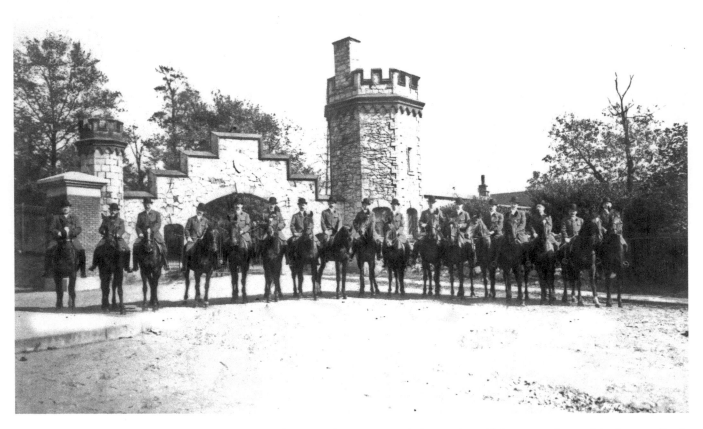

Fresh air and exercise were the order of the day for these members of the Hoboken Riding Club, seen in front of the Stevens Castle gate in 1904. Riding was popular in the heights above the Hudson River. The Hexamer Riding Club and the German Riding Club were two more clubs in the area. They frequently joined New York clubs for trips to the Adirondacks.

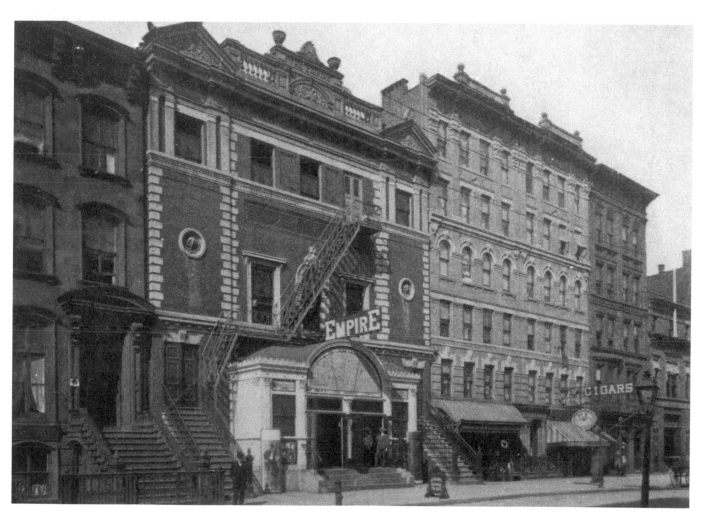

The Empire Theatre, seen around 1905, occupied this ornate building on Hudson Street.

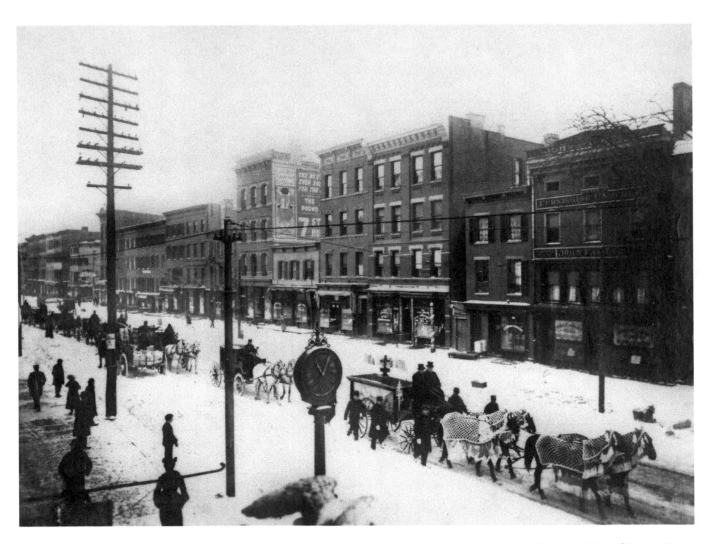

A horse-drawn hearse on Washington Street leads the funeral procession for Hoboken fire fighter William Buckley of Engine Five. Buckley perished in a blaze at the Elysian Supply Company Factory on January 2, 1905.

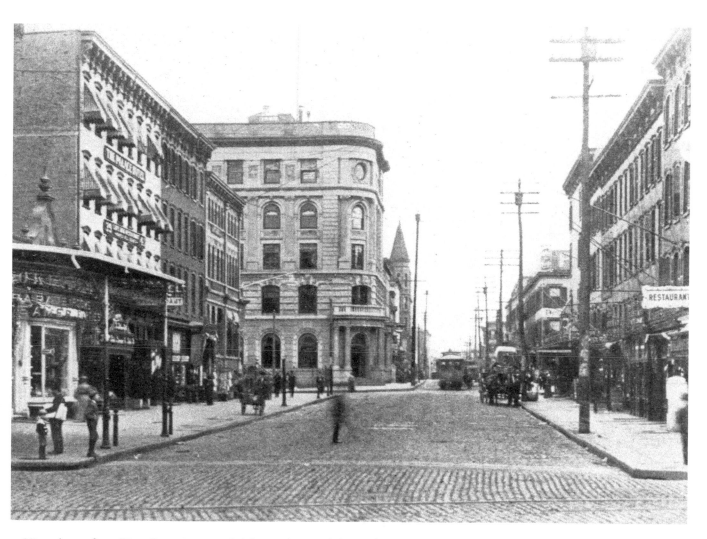

Viewed west from River Street in 1905, brick-paved Newark Street shows Hoboken as a mix of many worlds and many scenes, a turn-of-the-century mini-metropolis.

Located on 1st Street, the Roland cigar store is outfitted for a March 28, 1905, celebration of the 50th anniversary of Hoboken's incorporation.

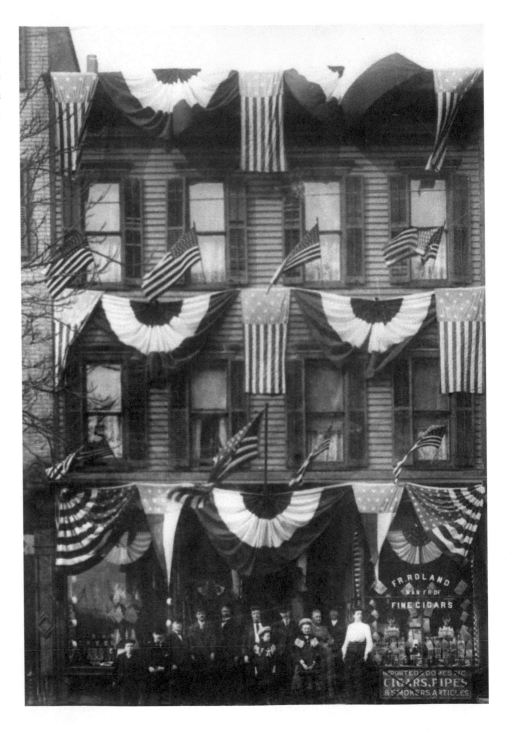

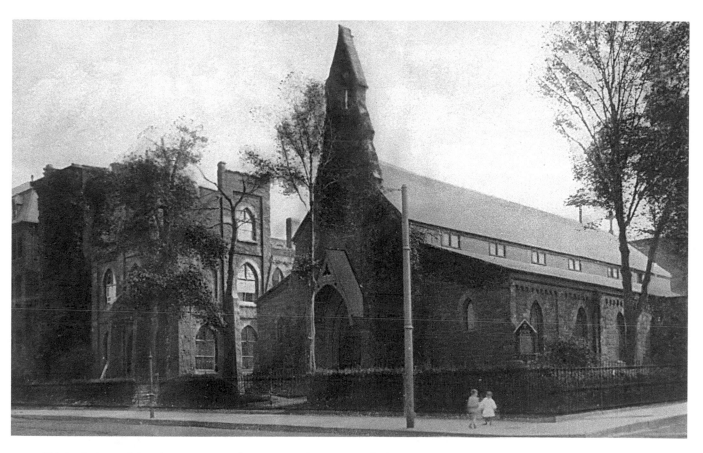

Trinity Episcopal Parish was organized in 1853 in the Town Hall above the fire house. The first service was held October 18, 1853. The current church, located at 7th and Washington streets and seen here in 1905, was completed in 1856. N. W. Camp was the first rector.

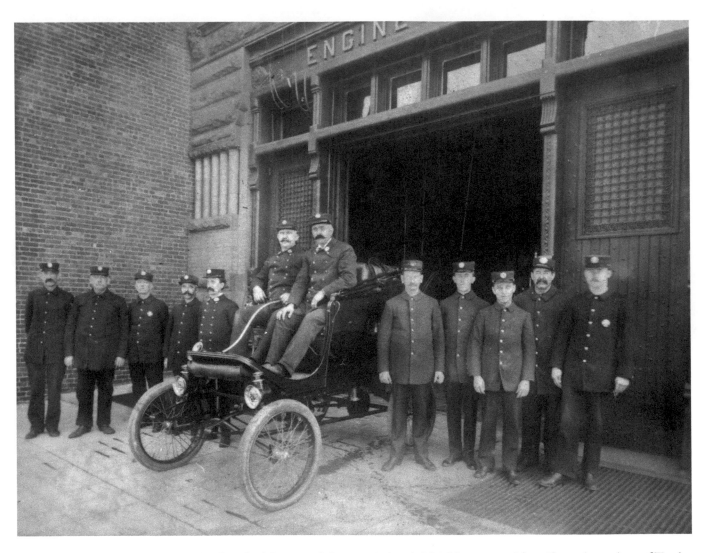

Seated in the fire department car, Chief Michael Dunn and Captain Arthur J. McMahon pose with uniformed members of Truck Company No. 1 (Engine Company No. 2) on Washington Street around 1908.

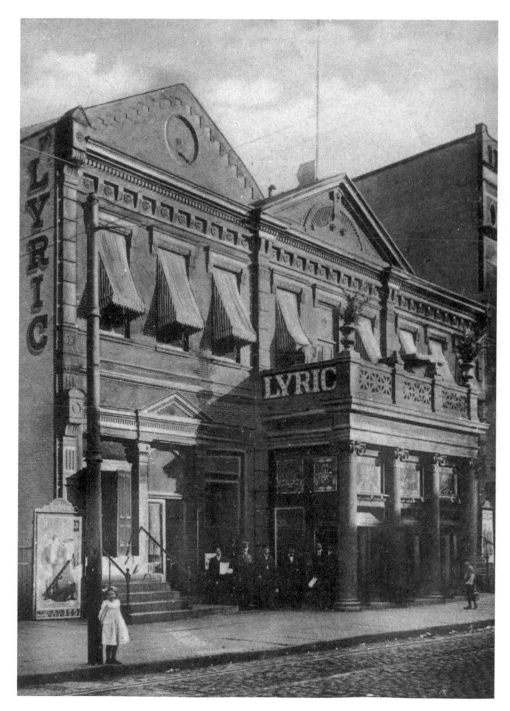

Hoboken's Lyric Theatre opened in 1886 and seated 1,800. Seen here in 1907, the venue hosted a variety of entertainers running the gamut from Lillie Langtry, to Burns and Allen, to Jack Benny. Located on Hudson Street, it would close in the mid-1940s.

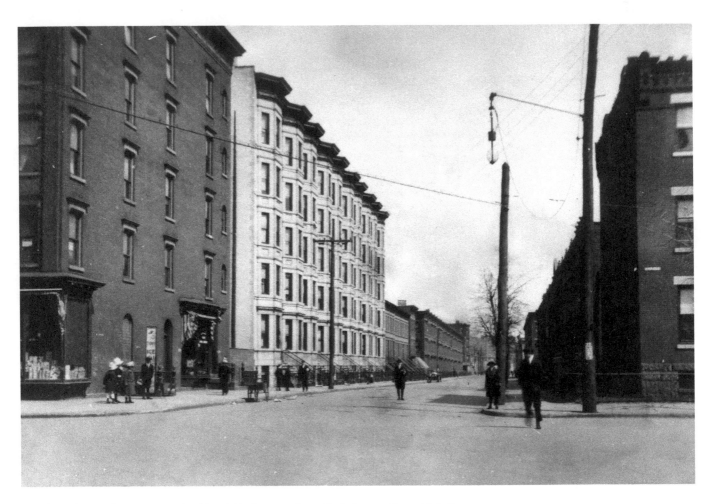

Buildings line wide city streets in this 1909 view north on Park Avenue from 11th Street.

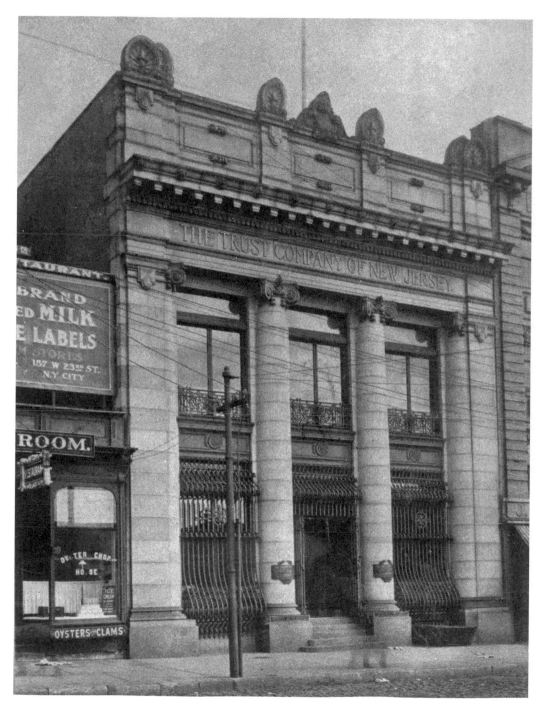

Chartered in 1899 and seen here a decade later, the Trust Company of New Jersey is located on Hudson Place. It was the fifth bank established in a city that used its geographic location to establish strong commercial ties.

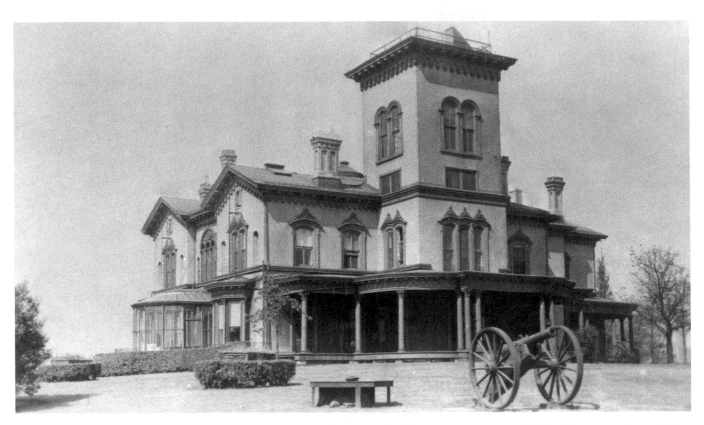

A Civil War cannon stands in front of the Stevens House on the grounds of the Stevens Institute of Technology around 1915. The institute was established as a mechanical engineering school but eventually incorporated other courses of study. It fosters a research environment and maintains rigid standards today. Noted alumni include sculptor Alexander Calder, creator of the mobile, and Alfred Fielding, co-inventor of bubble wrap.

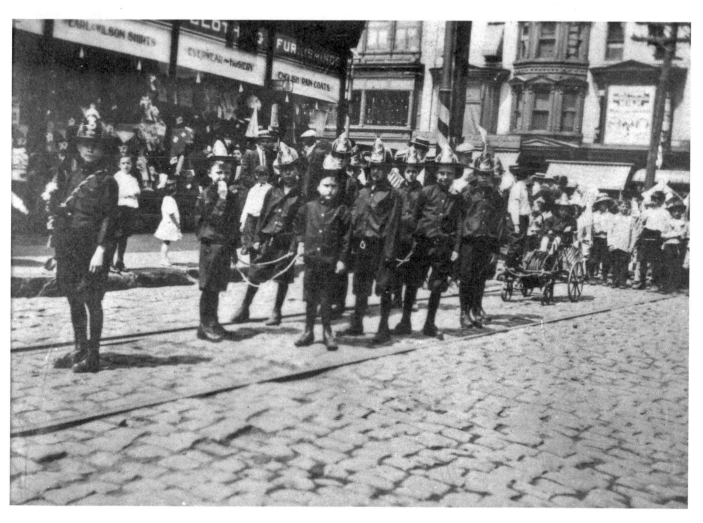

With very authentic-looking uniforms and their own fire wagon, youngsters dressed as Hoboken's bravest get ready to march in the Safe and Sane Parade around 1913.

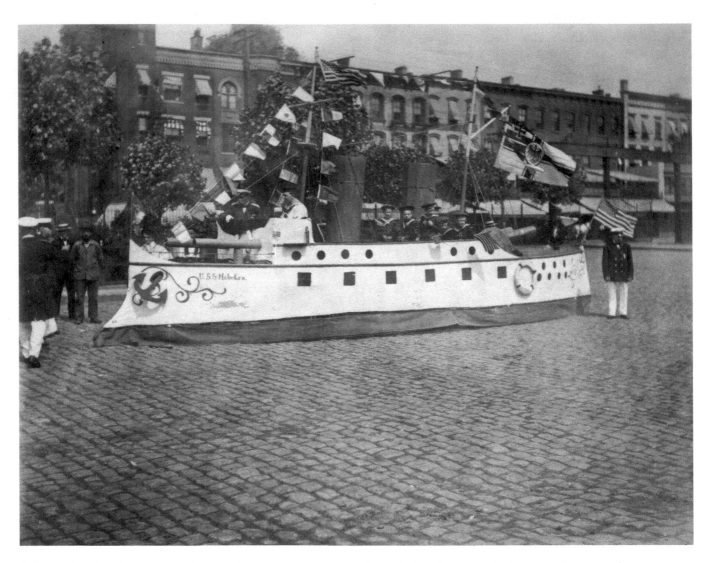

Safe and Sane Parades were started to promote more peaceful Fourth of July Parades, which had become dangerous due to fireworks and alcohol consumption. The 1913 Safe and Sane Parade included this model of the USS *Hoboken* presented by the North German Lloyd line and photographed on River Street. It was decorated with American and German Imperial flags.

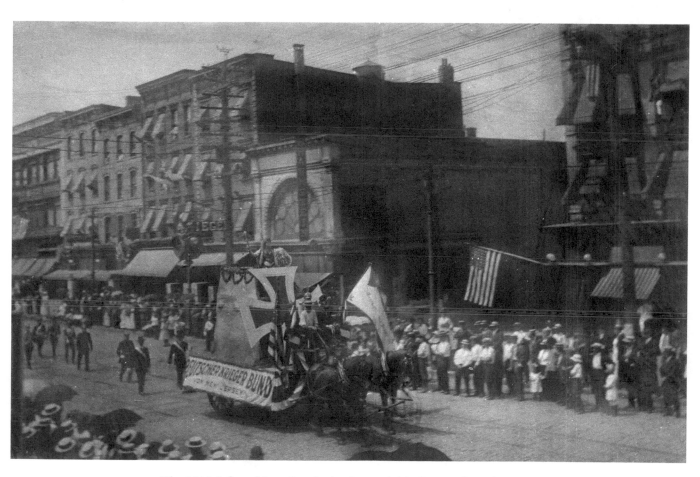

The 1913 Safe and Sane Parade also featured this German "Bund Von New Jersey" horse-drawn float.

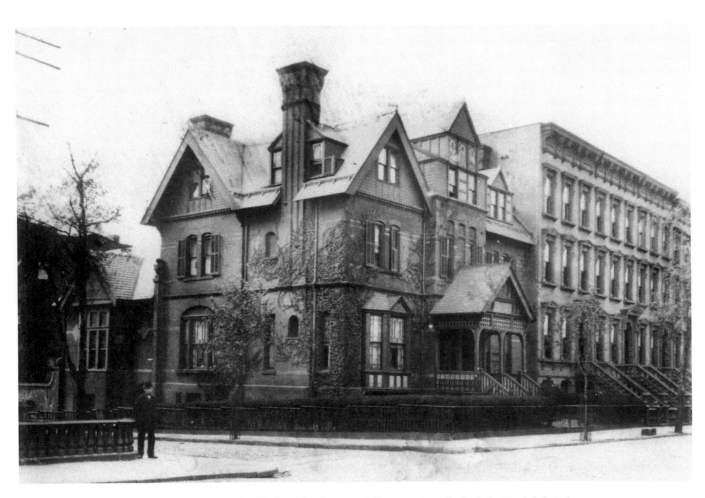

Hudson Street shows quite a mix of styles, highlighted by this stately house originally built by Rudolph Rabe.

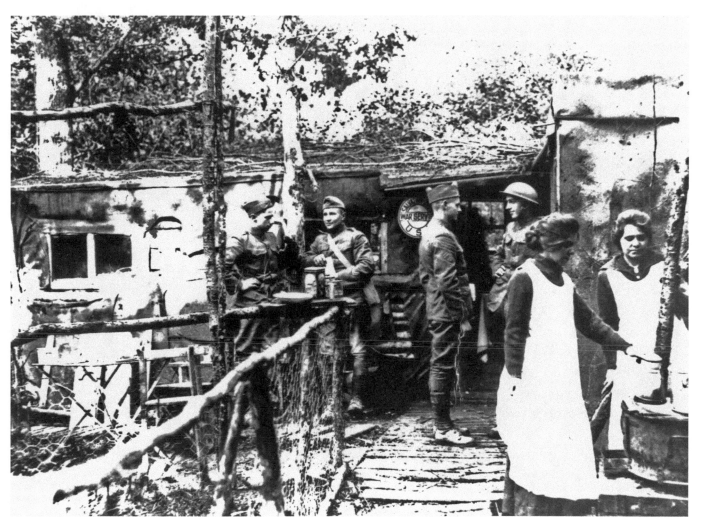

At a Hoboken location, young women from the USO branch of the Salvation Army prepare food for soldiers awaiting transport to the frontlines during World War I.

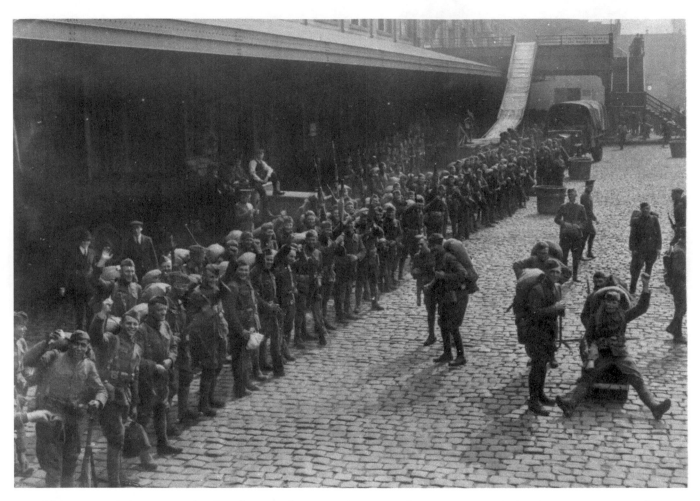

Doughboys at a Hoboken pier are lined up for embarkation on the SS *President Grant* in 1917. The *Grant* was a German ship that moored in a neutral port when World War I began. It was subsequently seized and used for troop transport. She served the military in World War II as well.

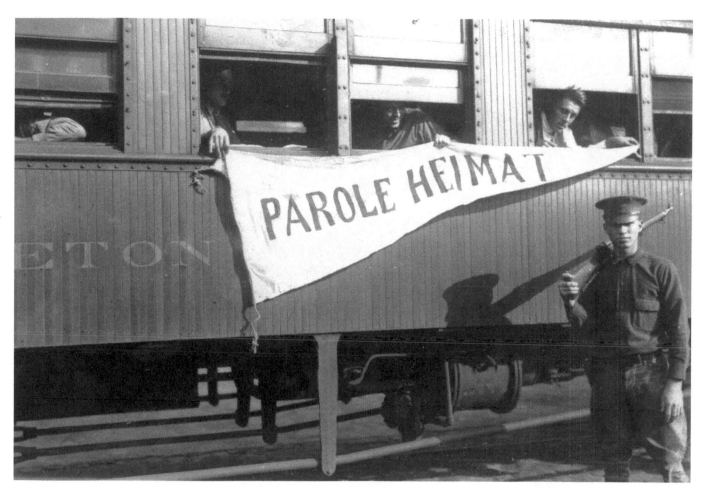

German aliens facing deportation upon America's entry into World War I arrive in Hoboken by special train from Oglethorpe, Georgia. More than 1,400 German nationals were transported on three trains. The "Parole Heimat" banner is loosely translated "Passport (or destination) Home."

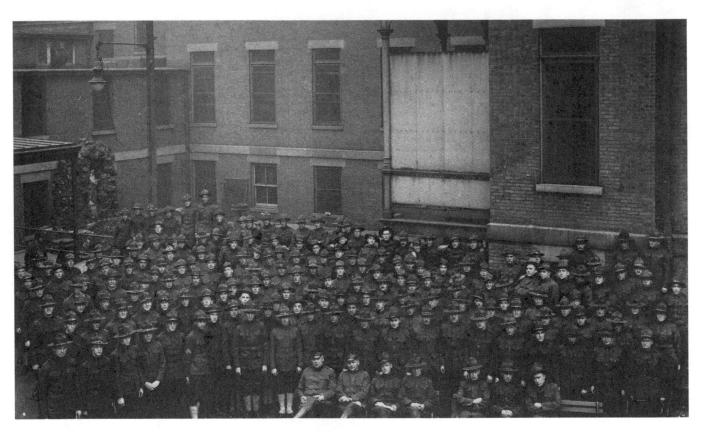

The USA Embarkation Hospital No. 1, seen here in 1917, was actually St. Mary's Hospital. The facility provided cantonments for men going to Europe or for wounded coming home, and could care for more than 700.

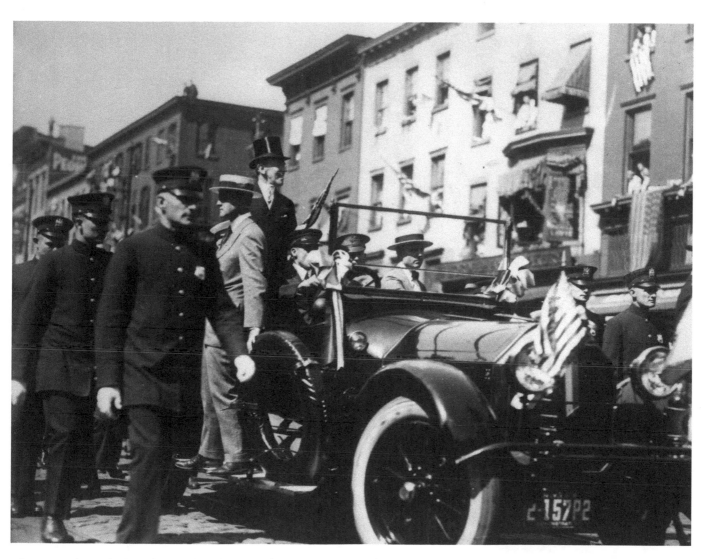

A motorcade carries President Wilson down Washington Street on July 8, 1919. A secret service agent stands alert on the running board of the president's car.

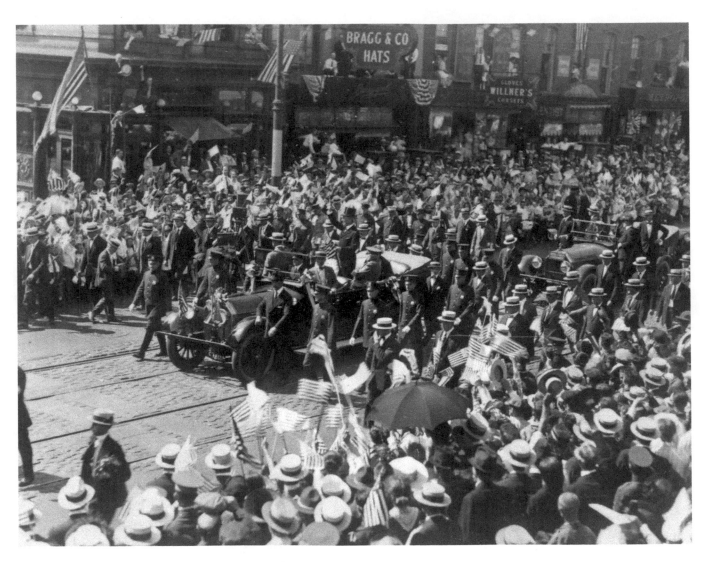

President Wilson's July 8, 1919, motorcade passes the Bragg & Company hat shop.

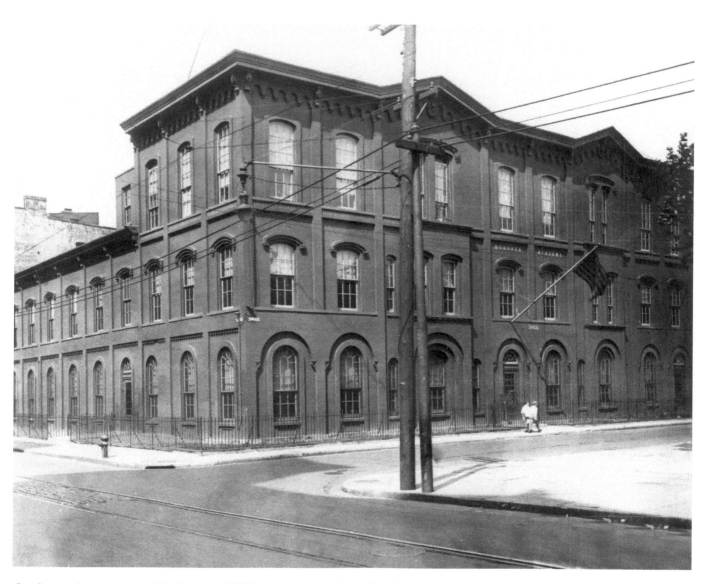

On the northeast corner of 5th Street and Willow Avenue stood the Hoboken Academy, established in 1861 as a German language and culture school. It is believed to have housed the first kindergarten in the United States. Merging with Stevens Prep in 1934, it became Stevens Academy in 1950 and closed in 1974. The building was demolished to make way for a bank.

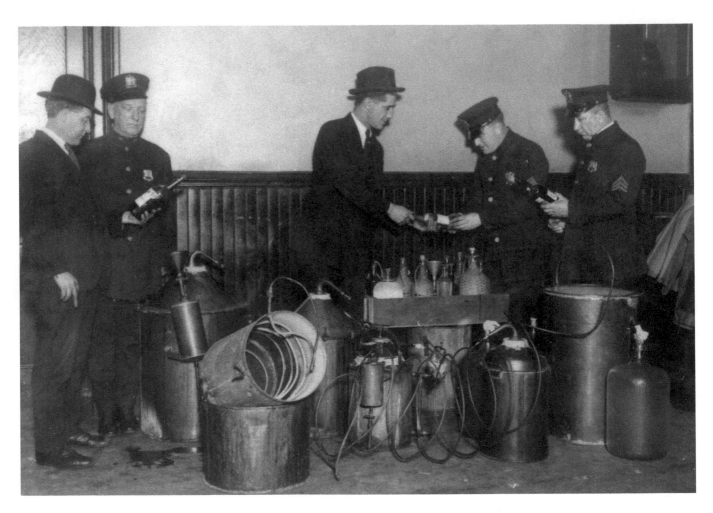

The Roaring Twenties brought increased illegal activity, especially in the production of liquor outlawed by Prohibition. Here a Hoboken raid has resulted in confiscation of paraphernalia for making "bathtub gin." Added vigilance may have stemmed from a January 1921 incident in which six residents died from wood-alcohol poisoning.

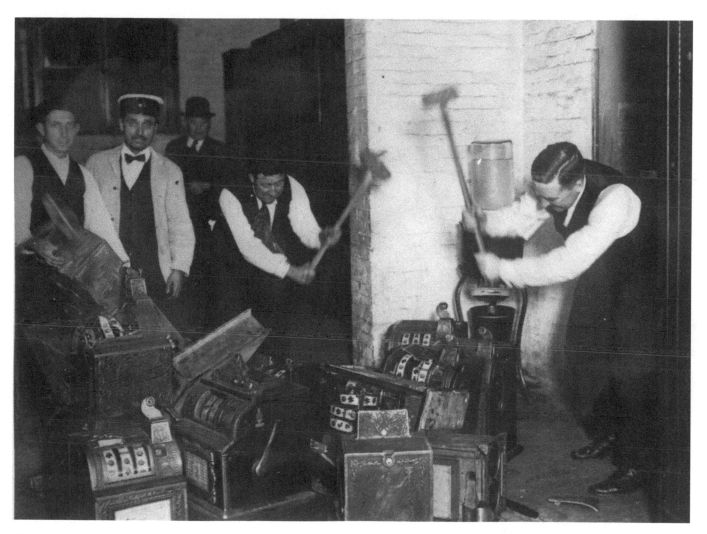

In the 1920s social vices were not confined to imbibing alcoholic beverages, though some would say liquor went arm-in-arm with the illegal "one-armed bandits." Here Hoboken detectives take sledgehammers to confiscated gambling equipment.

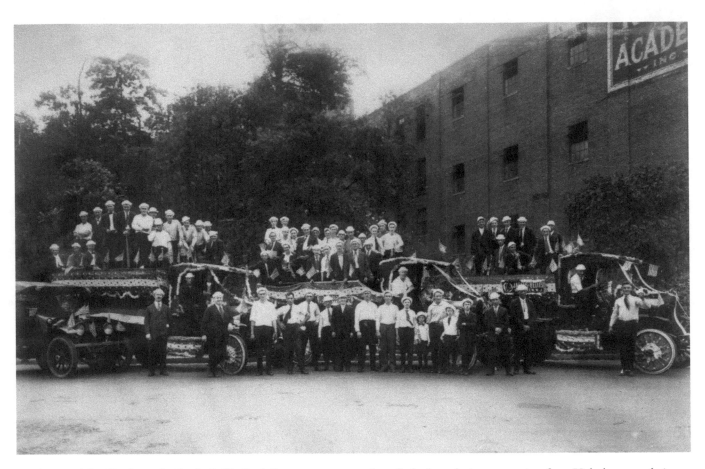

Workers and families from the Jagels-Bellis Coal Company pose on three flatbed trucks in preparation for a Hoboken parade in 1920. With its wide thoroughfares, Hoboken loved and still loves a parade. The coal business was lucrative in the city. Coal stoves were in Hoboken homes, and coal boilers powered shipping.

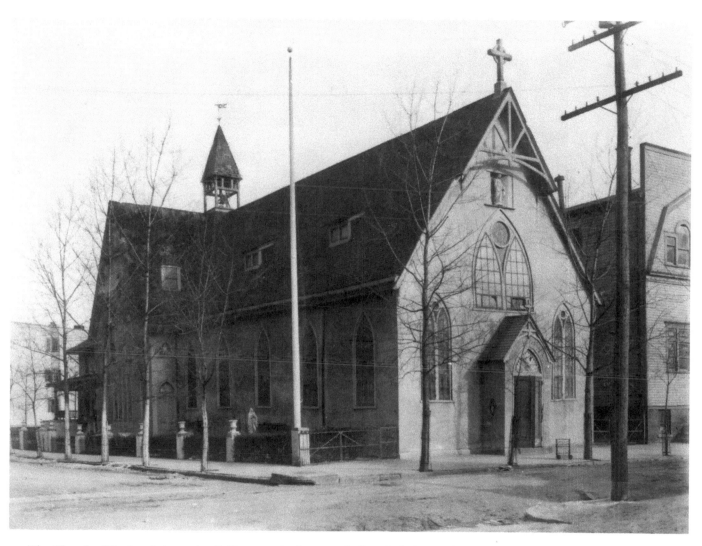

The Church of St. Ann is located at Jefferson and 7th streets. Italian Catholics of the area who had been meeting in a basement at 4th and Jefferson moved to a storefront right after the turn of the century. Masses were said in a makeshift chapel. As the congregation grew, plans for a church materialized and this *Parochia di S. Anna* opened in 1906. St. Ann's feast day is July 26, so a *festa,* or celebration, was instituted that carries on to this day, though the church has since moved.

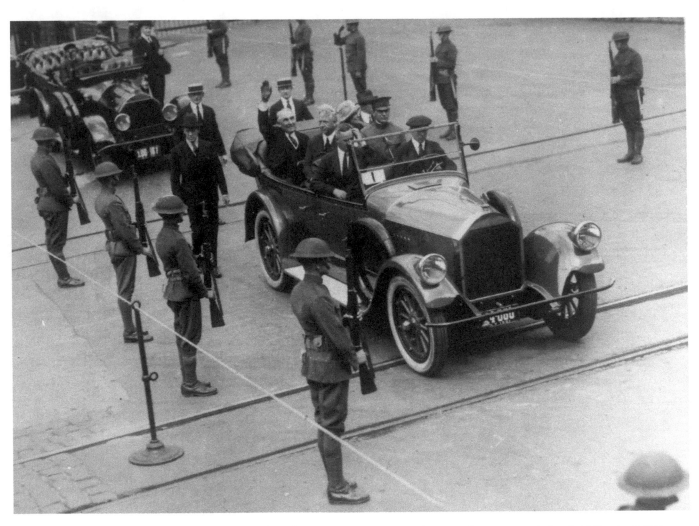

President Warren G. Harding waves to the crowd on the Army Piers on May 24, 1921. Services were being held for the 5,212 war dead being returned from military cemeteries in France aboard the transport ship *Wheaton*. Representatives from all states in the Union as well as a multitude of European officials attended.

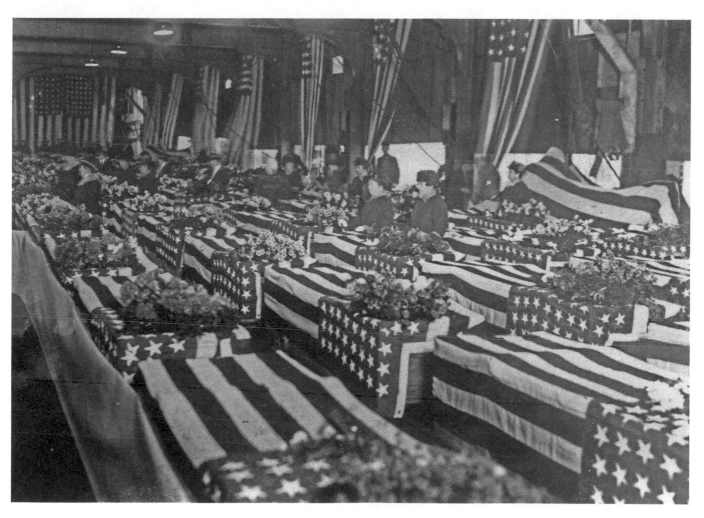

Coffins draped with flowers and the American flag are lined up inside one of the pier buildings after being removed from the *Wheaton* on May 24, 1921. Women of the Hoboken War Mothers are placing the bouquets.

At a Hoboken ceremony on July 10, 1921, General Pershing, Commander of the American Expeditionary Forces in World War I, and Senator Henry Cabot Lodge are among those present to honor the first three American soldiers who died in France.

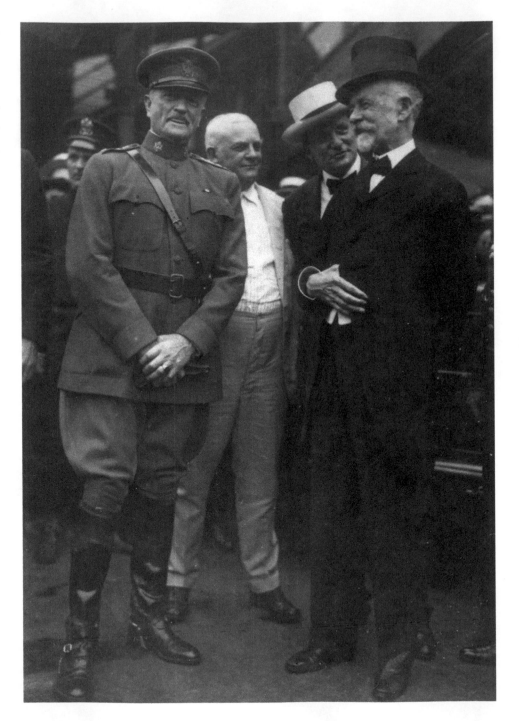

The Hofbrau Haus
restaurant and Central
Hotel occupy the corner
of River and 2nd streets
here in the late 1920s.
The street-level eatery
had booths and tables
inside and a bandstand
outside during summer.
The business in 1925
had 10,000 capital
shares outstanding, so
it must have been a
profitable undertaking.

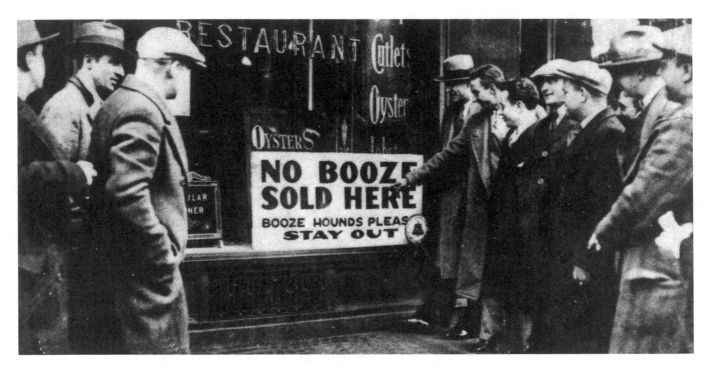

By 1929, Prohibition had nearly run its course. In a town like Hoboken, which was once advertised as having a bar on every corner, speakeasies flourished. It got to the point where restaurant owner George Gonzales had to advertise—along with promoting his cutlets and oysters—that "booze hounds" should take their business elsewhere.

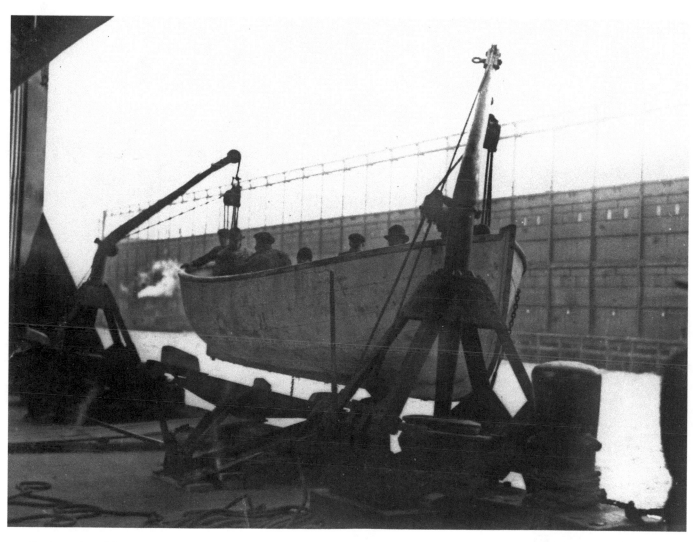

In the wake of the *Titanic* disaster of 1912, pressure was brought to bear on the shipping industry to improve safety. Hoboken was a maritime city, and various devices intended to make shipping safer were tested in its shipyards. Here lifeboat designs and equipment are being tested in January 1921.

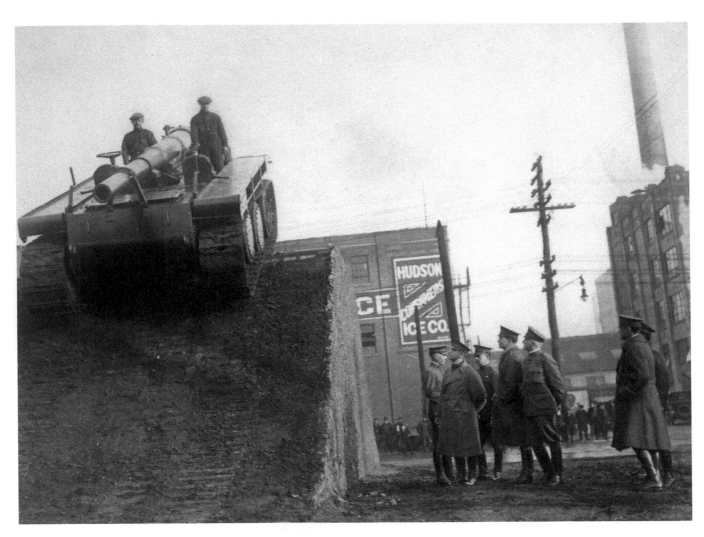

After World War I, the drive to replace horse cavalry with mechanized equipment was under way. Here in December 1920 near Hoboken's Hudson Ice Company, military officials and a large group of onlookers scrutinize a "new type" 155-mm rifle mounted on a caterpillar track vehicle.

Off and on the Waterfront

(1930–1970s)

Seen here in the 1930s, Our Lady of Grace Orphanage on Willow Avenue between 4th and 5th streets was associated with Our Lady of Grace Church.

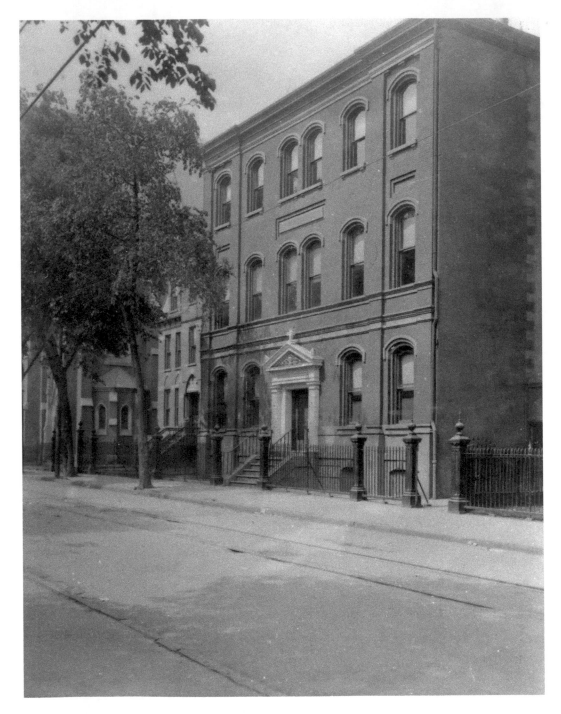

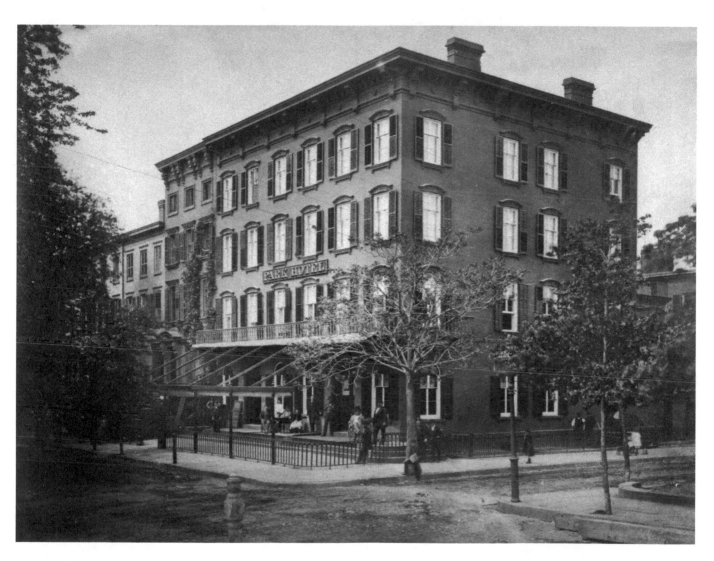

The Park Hotel with its spacious front porch was located at 4th and Hudson streets. It was reported that Baron Ulrich Von Puttkamer, Bismarck's nephew, caused quite a stir when he lodged at the hotel after having left the Prussian Army following a dispute with one of his commanders in 1885.

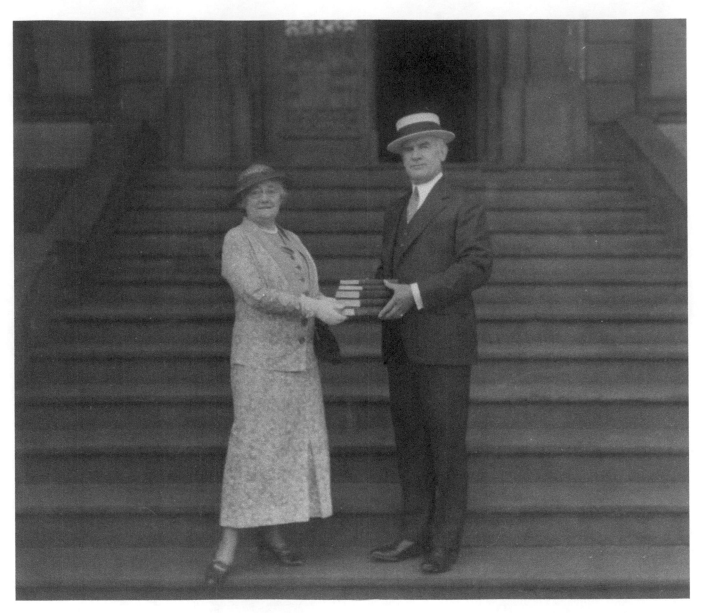

During Citizen Gift Book Week in June 1936, librarian Nina Hatfield accepts books from Mayor B. N. McFeely on the steps of City Hall. As Hoboken's mayor from 1930 to 1947, McFeely led the city through the Great Depression and World War II.

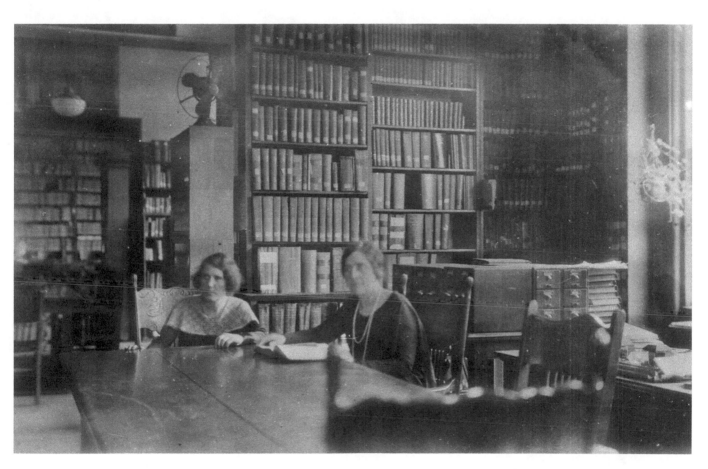

These two women are perusing materials at the Hoboken Public Library in 1933 in what is probably the reference department.

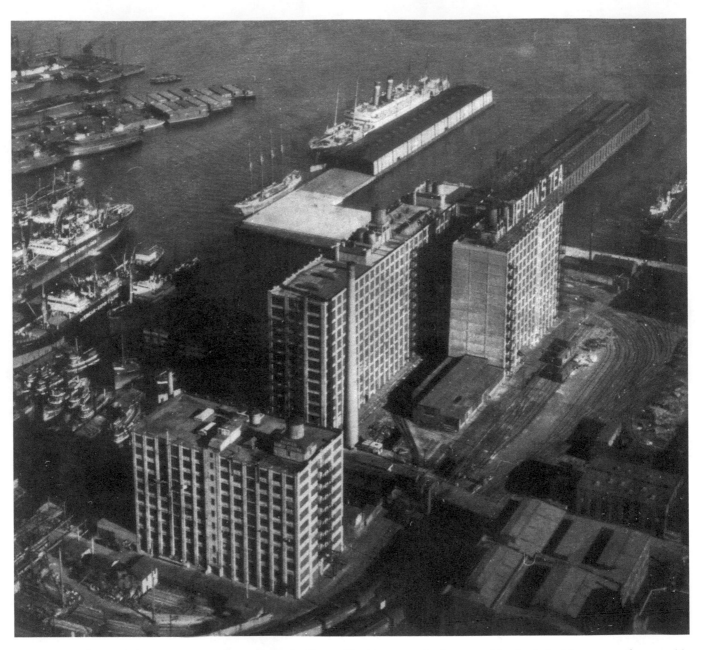

A 1930s aerial view of the uptown waterfront shows the Lipton Tea Company. In the cove, ships loaded with cargoes of tea would anchor and unload directly onto the piers. Sir Thomas Lipton was a member of the Hoboken Chamber of Commerce in 1919.

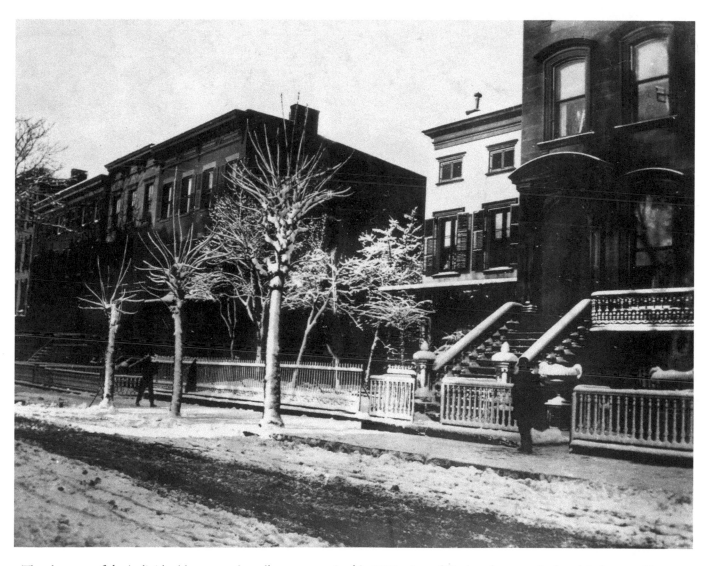

The closeness of the individual homes and small apartments in this 1930s view of Hudson between 2nd and 3rd streets illustrates the tight quarters of the port cities built early on in America. People lived near to where they worked because they traveled on foot to their jobs. Large docks and warehouses employed many people, so neighbors learned one another's habits very well.

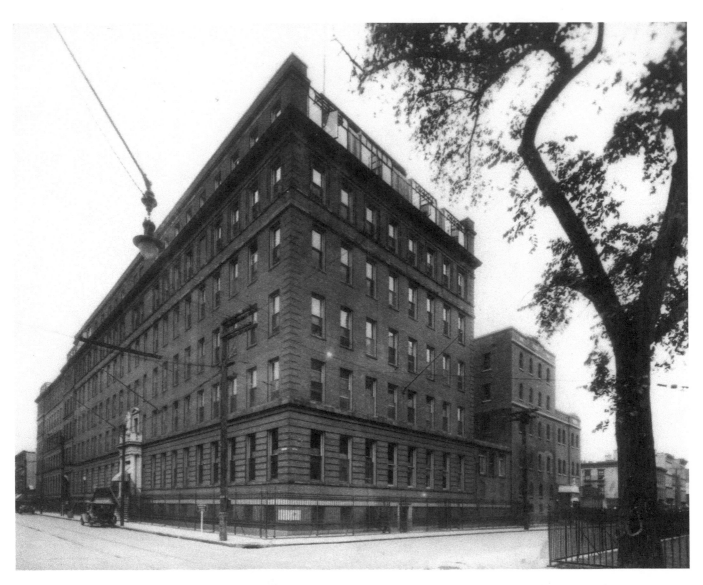

By the 1930s, as seen here, St. Mary's Hospital had reached another stage of development, matching the city's needs.

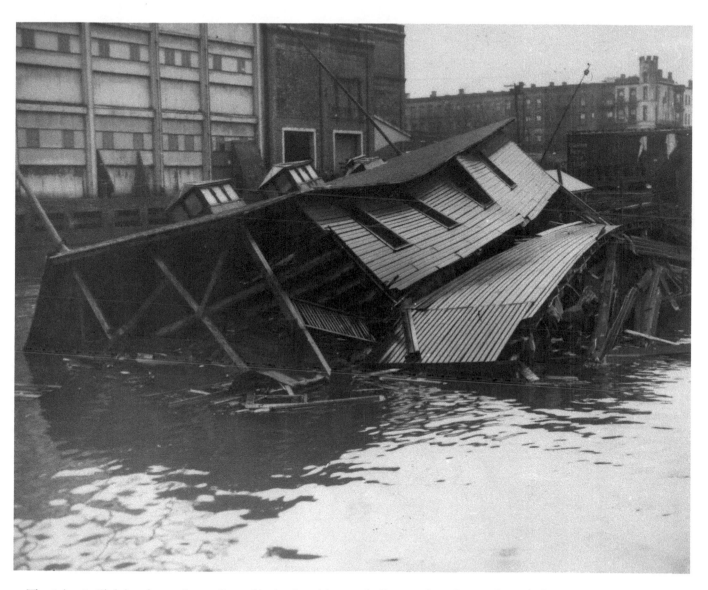

The Atlantic Club boathouse, here collapsed in April 1946, was rebuilt a number of times through the years. Organized in 1858 by the Tuthill Brothers, the Atlantic Club was victorious in numerous rowing races on the Hudson River. By 1893 the club claimed to be the second-oldest rowing association in the United States.

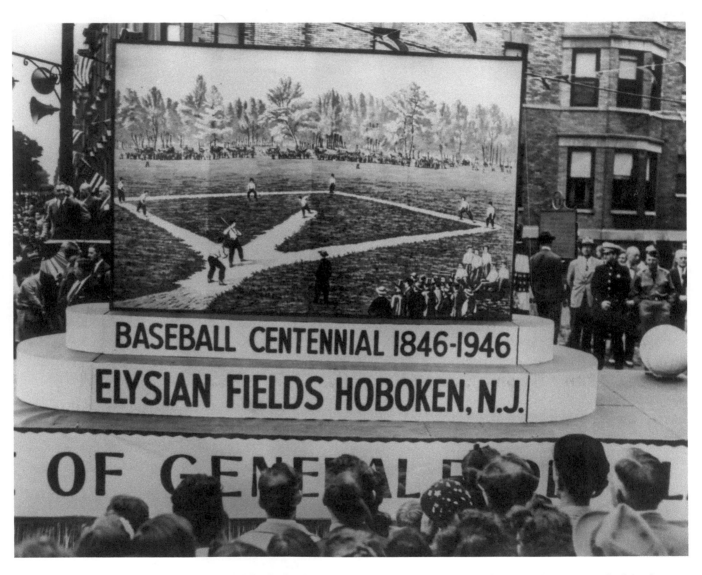

Move over Cooperstown; Hoboken claims to be the birthplace of baseball. In 1946, the city honored the centennial of the first organized game played at the Elysian Fields. This parade float depicts the event.

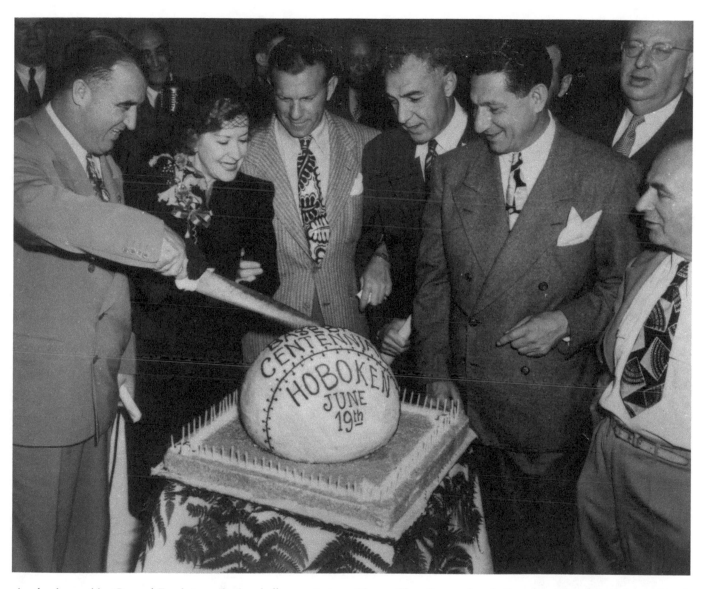

A cake donated by General Foods is cut by baseball commissioner Happy Chandler at a baseball centennial party at Meyers Hotel. Looking on from left to right are radio personalities Gracie Allen and George Burns, National League commissioner Ford Frick, and the famous "Clown Prince of Baseball," Al Schacht.

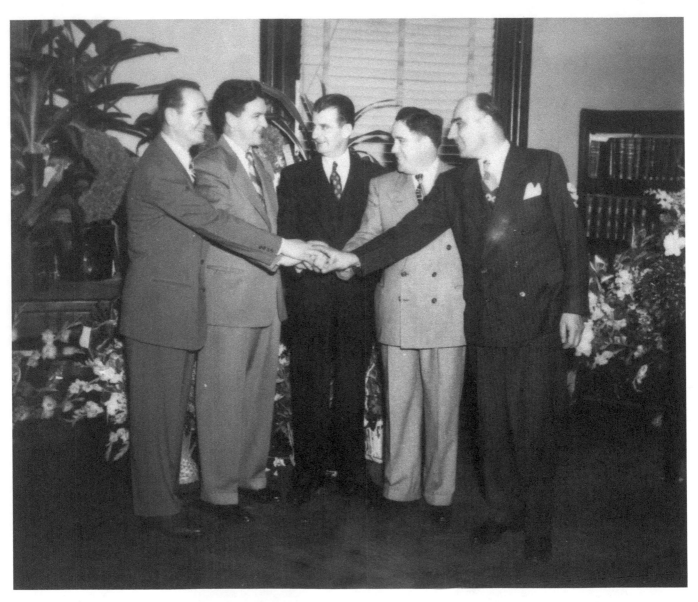

Congratulations all around inside Mayor Fred De Sapio's office in 1947 as the mayor, at left, meets with Hoboken city commissioners Grogan, Borelli, Fitzpatrick, and Mongiello, as seen left to right.

Election Day, May 8, 1948, drew a large and energetic crowd to Hoboken City Hall.

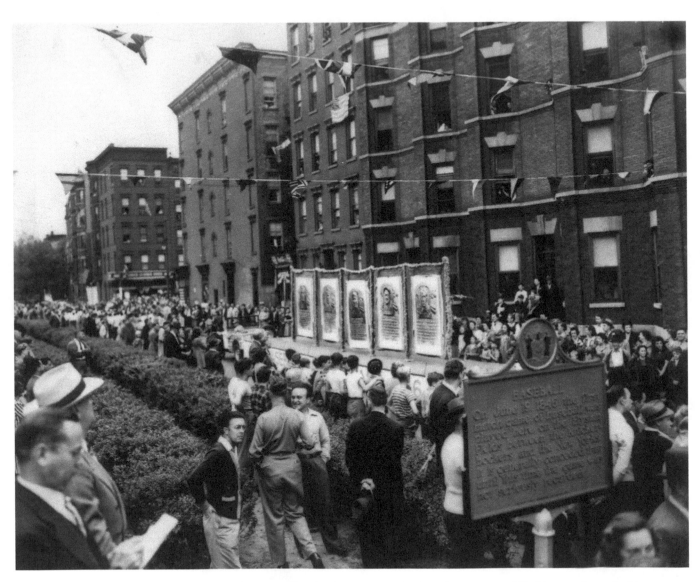

The plaque commemorating "the first match game of baseball" is on Hoboken's 11th Street near Washington Street looking east.

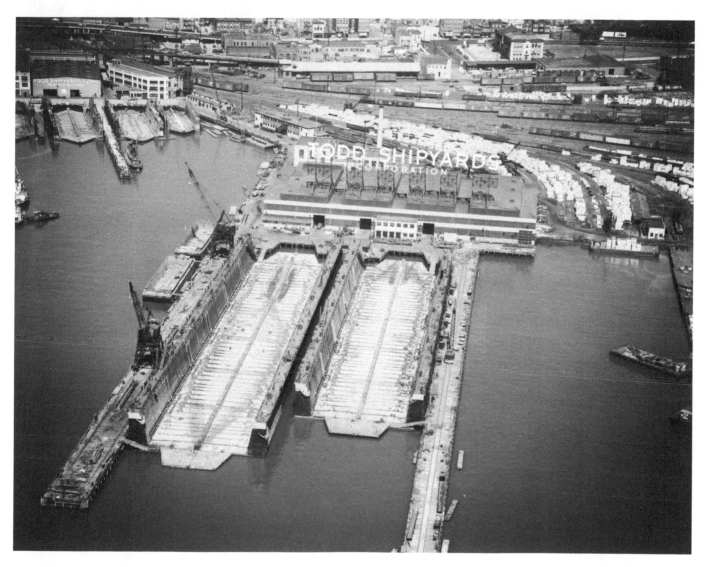

This is a 1951 view of Todd Shipyards on 17th Street, originally the Tietjen and Lang Shipyard, where Frank Sinatra once worked. Todd incorporated several such yards on the East and West coasts and luckily was able to survive the Great Depression. Between December 7, 1941, and August 31, 1945, over 23,000 auxiliary naval ships essential to the war effort were produced by Todd.

During the 1930s in
Hoboken, railroad cars
were loaded on ships
to be transported as far
away as Havana, Cuba.
In 1945 the aptly named
Seatrain line took over
the pier. Business was so
good that the Hoboken
Shore Railroad was later
established for movement
along the waterfront.

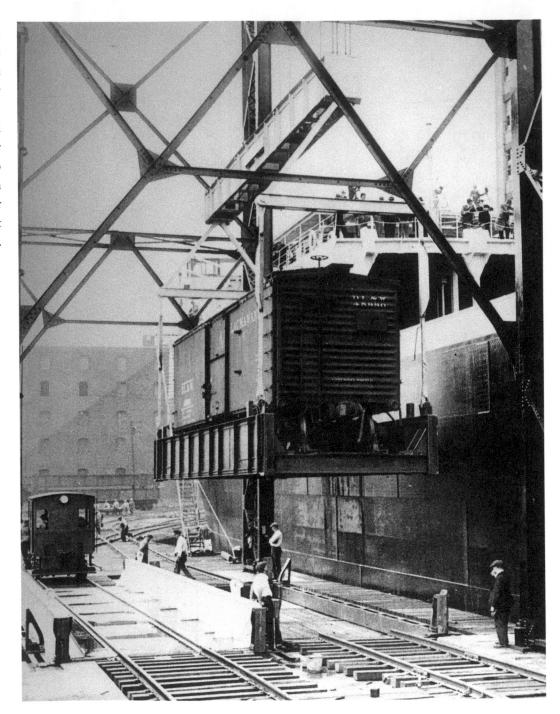

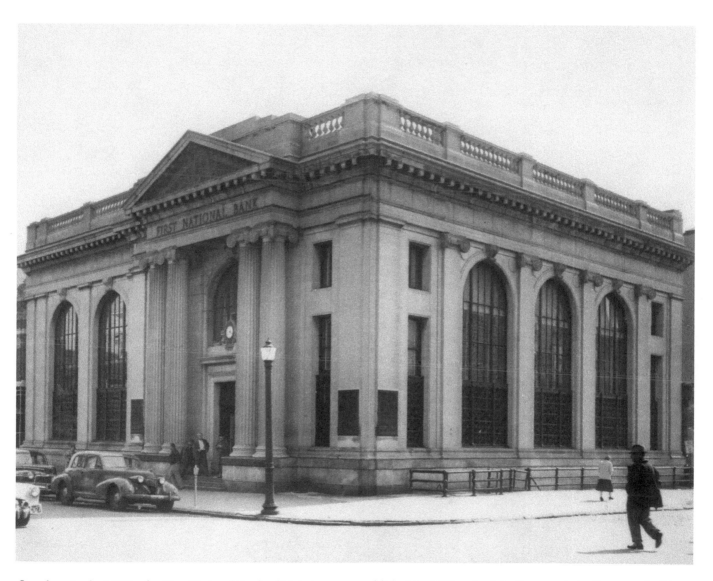

Seen here in the 1950s, the First National Bank of Hoboken was established in 1865 and originally occupied a five-story building. The bank later merged with the Hudson Trust Company; its first executive leader was S. Bayard Dod, a former minister.

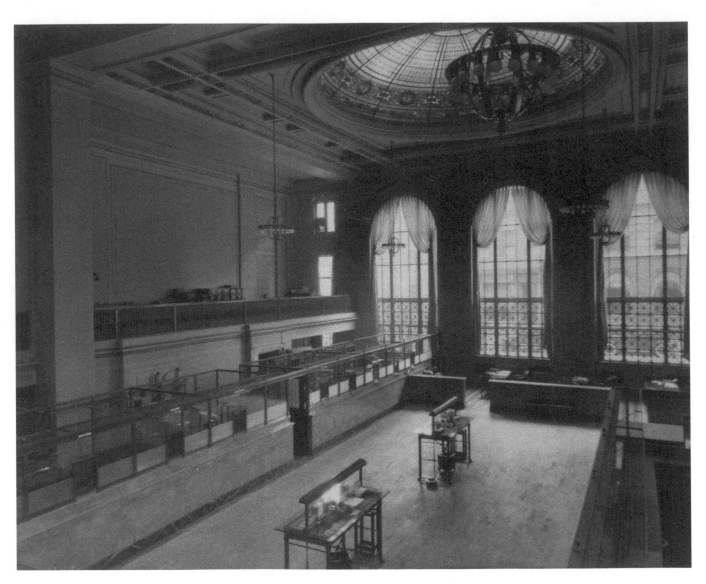

The elegant interior of the First National Bank at Newark and Hudson streets featured an ornate chandelier and a ceiling with a stained-glass dome.

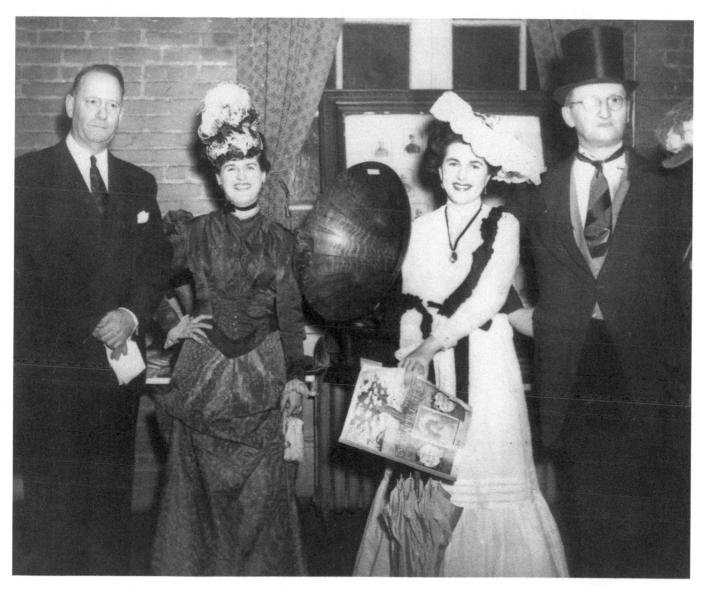

George Miller, Mary and Frances Caughlin, and Adolph Rochich pose at the Waldheim-Stevens Forum during a 1950s celebration. Philip Waldheim was a wealthy leather merchant who in his will bequeathed $75,000 to establish the Public Forum for the Exchange of Ideas in 1921. This soiree was held at 916 Garden Street, now the site of Hoboken's first automated parking garage.

Hoboken ferries ran continuously for 145 years until 1967 and operated the last steam ferry on the Hudson. This Barclay Street location, originally the Hoboken Ferry Company, would be active from half an hour before sunrise until eight or nine at night, depending on the season.

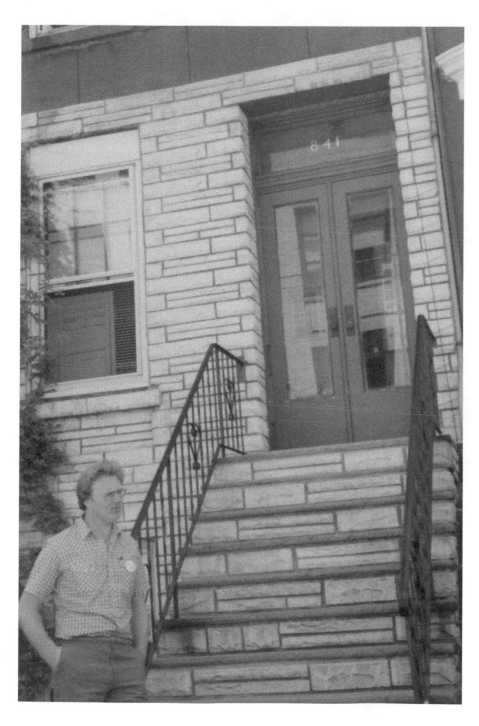

The house at 841 Garden Street in Hoboken was the Sinatra family home when Frank Sinatra was a teen.

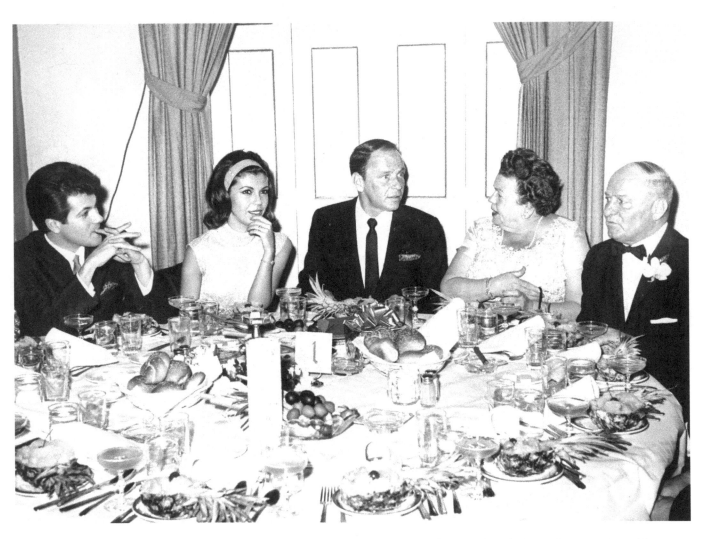

Celebrating the 50th wedding anniversary of Martin and Natalie Sinatra in Hoboken are, from left to right, actor-singer Tommy Sands; Nancy Sinatra, Frank's daughter; Frank; and Natalie and Martin, Frank's parents.

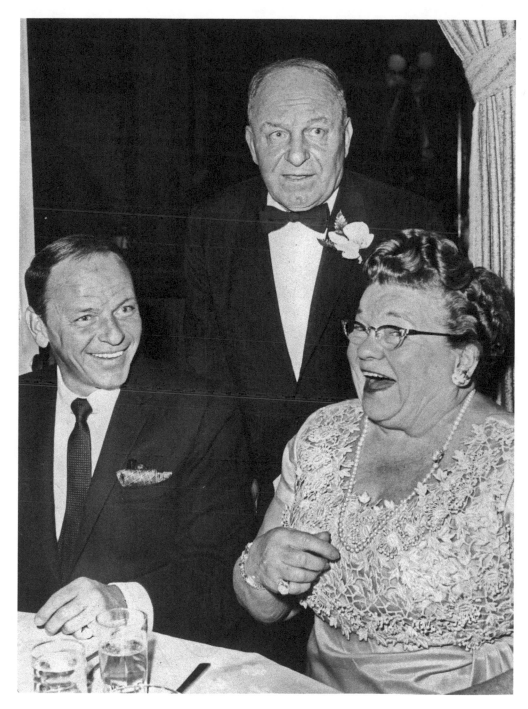

This close-up of the Sinatra family shows quite a resemblance between Frank and his father. Martin Sinatra was a boxer for a short time before operating a tavern called Marty O'Brien's, the name he boxed under. He later became a captain in the Hoboken Fire Department. Natalie Sinatra worked as a barmaid at Marty's and was a Democratic Party ward boss who could guarantee 500 votes on Election Day.

Notes on the Photographs

These notes, listed by page number, attempt to include all aspects known of the photographs. Each of the photographs is identified by the page number, a title or description, photographer and collection, archive, and call or box number when applicable. Although every attempt was made to collect all data, in some cases complete data may have been unavailable due to the age and condition of some of the photographs and records.

Printed in the USA
CPSIA information can be obtained
at www.ICGtesting.com
JSHW072021140824
68134JS00042B/3732